Remembering Mobile

Carol Ellis and Scotty E. Kirkland

TURNER
PUBLISHING COMPANY

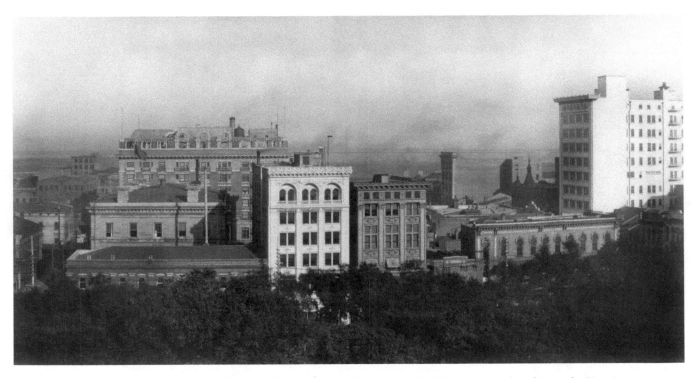

A panoramic view of Mobile taken from the roof of the Cawthon Hotel around 1909. Among other things, the Van Antwerp Building and the tops of trees in Bienville Square are visible.

Remembering
Mobile

Turner Publishing Company
4507 Charlotte Avenue • Suite 100
Nashville, Tennessee 37209
(615) 255-2665

Remembering Mobile

www.turnerpublishing.com

Library of Congress Control Number: 2010926203

ISBN: 978-1-59652-677-8

Printed in the United States of America

ISBN: 978-1-68336-856-4 (pbk)

10 11 12 13 14 15 16—0 9 8 7 6 5 4 3 2 1

CONTENTS

Mobilians came to the Empire Theater on Dauphin Street in 1920 to see Norma Talmadge's *She Loves and Lies,* a comedy about a heiress with multiple personalities. Patrons paid 25 cents for adult tickets. This photograph was taken some years before the Hays Code censored movies like *Sex,* starring Louise Glaum, advertised to the left.

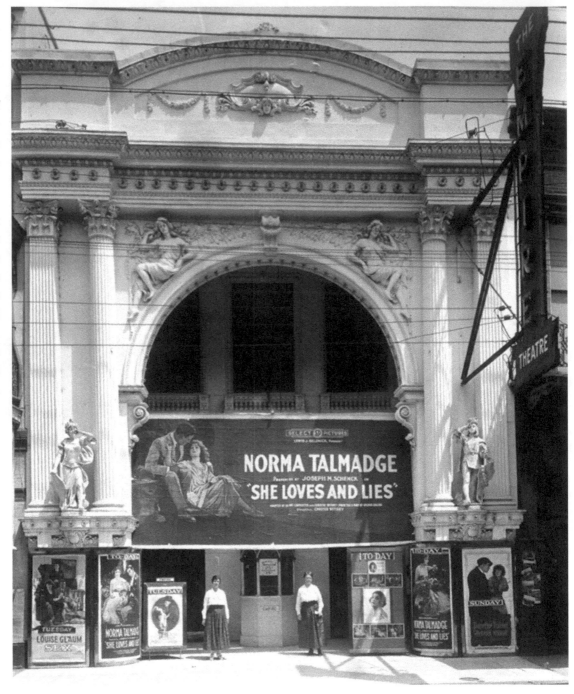

Acknowledgments

This volume, *Remembering Mobile,* is the result of the cooperation and efforts of many individuals, organizations, and corporations. It is with great thanks that we acknowledge the valuable contribution of the following for their generous support:

Clarke County Historical Society

Harris Photo Company

Library of Congress

Mobile Public Library

Museum of Mobile

University of South Alabama Archives

The authors would also like to thank the following individuals for valuable contributions and assistance in making this work possible:

Michael Thomason and Lisa Baldwin, their predecessors at the archives, and Barbara Asmus

PREFACE

A photograph is a powerful medium. It evokes memories, emotions, and questions. There are thousands of photographs of Mobile residing in archives, both locally and nationally. The goal in publishing this work is to disseminate more widely the extraordinary photographic history of the city of Mobile. We seek to preserve the past with respect and reverence, and hope the images in this book offer an original, untainted perspective that will allow the reader to interpret and observe them.

This project represents the collaboration between Turner Publishing and the University of South Alabama Archives. The researchers and writers reviewed the thousands of photographs contained in the university's archives, selecting those we thought the reader would most like to see. We supplemented those images with photographs from several other local sources as well as the Library of Congress. We greatly appreciate the generous assistance of the individuals and organizations listed in the acknowledgments section of this work, without whom this project could not have been completed.

With the exception of touching up imperfections that have accrued with the passage of time and cropping where necessary, no changes have been made. The focus and clarity of many images are limited to the technology and the ability of the photographer at the time they were recorded.

The work is divided into eras. Beginning with some of the earliest known photographs of Mobile, the first section records the city through the end of the nineteenth century. The second section spans the beginning of the twentieth century through World War I. The following three sections cover the 1920s, 1930s, and 1940s respectively. The concluding section documents the changes that occurred between 1950 and 1969.

We have made an effort to capture various aspects of life in Mobile through our selection of the images herein. To provide a broad outlook, we have included photographs of people, commerce, transportation, infrastructure, religious institutions, and educational institutions.

We encourage readers to reflect as they go walking in Old Mobile. Stroll through the city, its parks, and

its streets. It is the publisher's hope that in utilizing this work, longtime residents will learn something new and that new residents will see where Mobile has been, so that each can contribute to its future.

—Todd Bottorff, Publisher

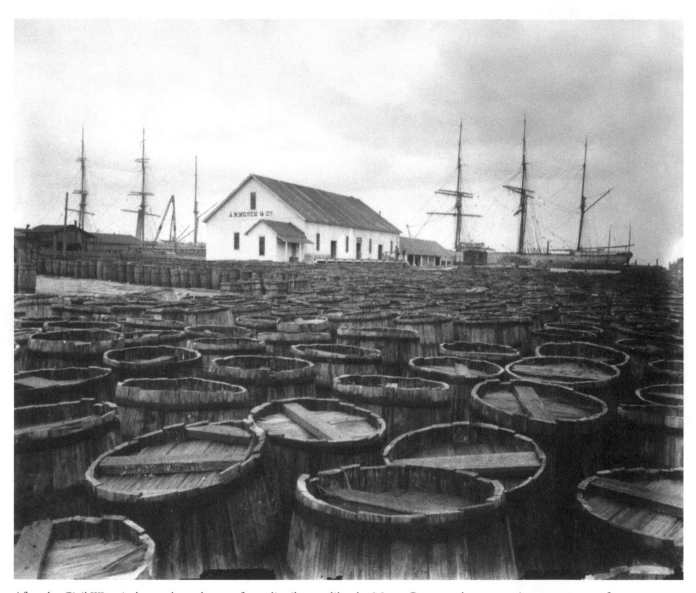

After the Civil War, timber and naval stores from distributors like the Moses Company became an important part of Mobile's economy.

NEW SOUTH CITY

(1870–1899)

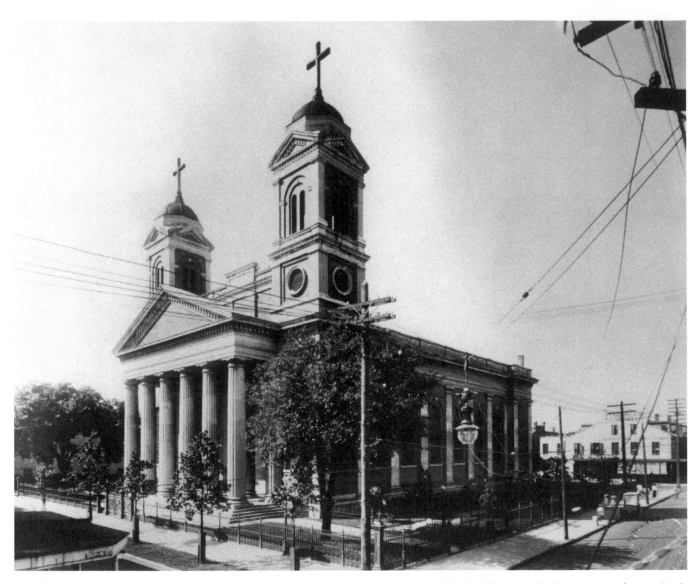

Northeast view of the Cathedral of the Immaculate Conception. The cornerstone of the building was laid in 1835, and it was built between 1834 and 1849 by the architect Claude Beroujon.

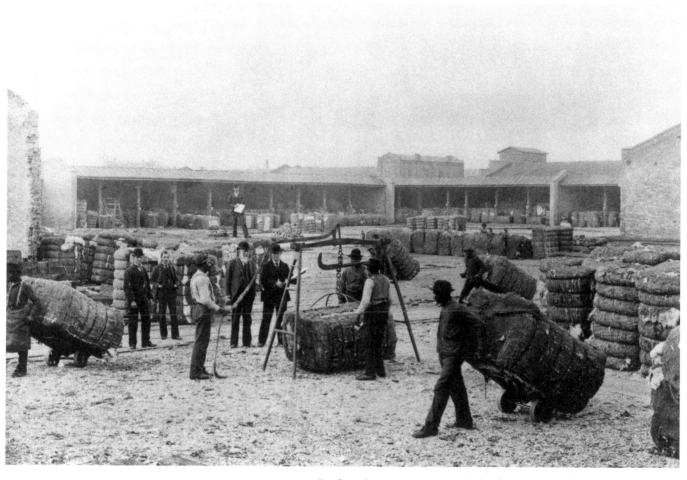

Dockworkers prepare cotton bales for transport from Mobile in 1894.

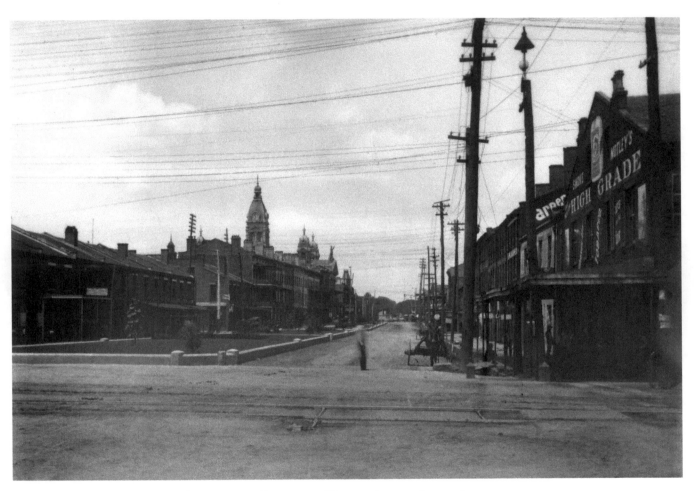

Government Street, looking west from Duncan Place, 1895. The courthouse spires can be seen.

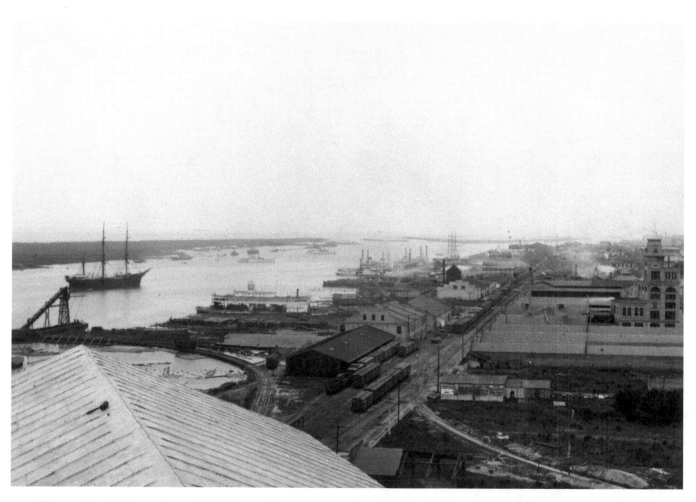

Chartered in 1848 to enhance Mobile's appeal as a commercial center, the Mobile & Ohio Railroad dominated the waterfront by 1895.

The fourth Mobile County Courthouse (1889–1957), designed by Rudolph Benz. This 1895 image shows how ornate the structure was. Erected at a cost of $50,000, it included pilasters, towers, and statuary, as well as a portico, a gable, and an 86-foot clock tower. The statue of the woman holding the flame can now be seen in the atrium of the Museum of Mobile.

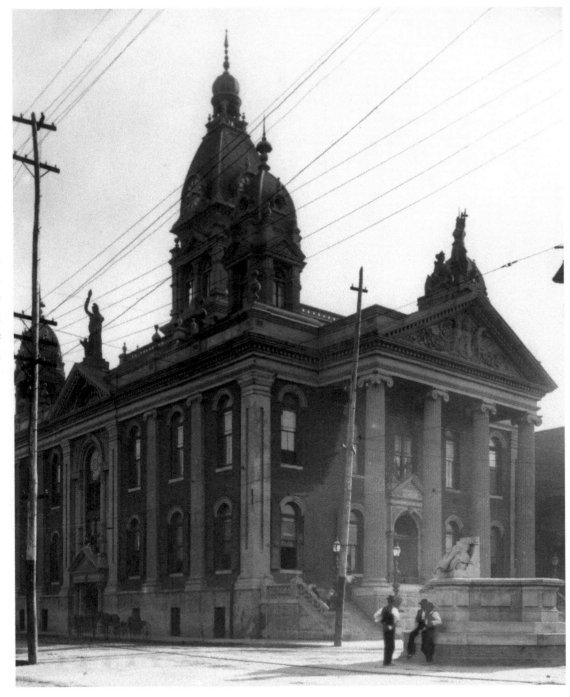

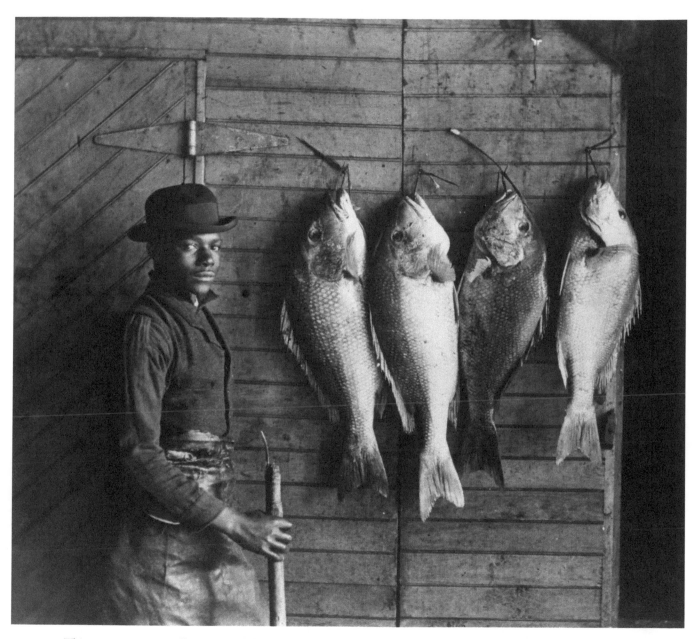

This young man proudly poses with his catch of red snapper (ca. 1895).

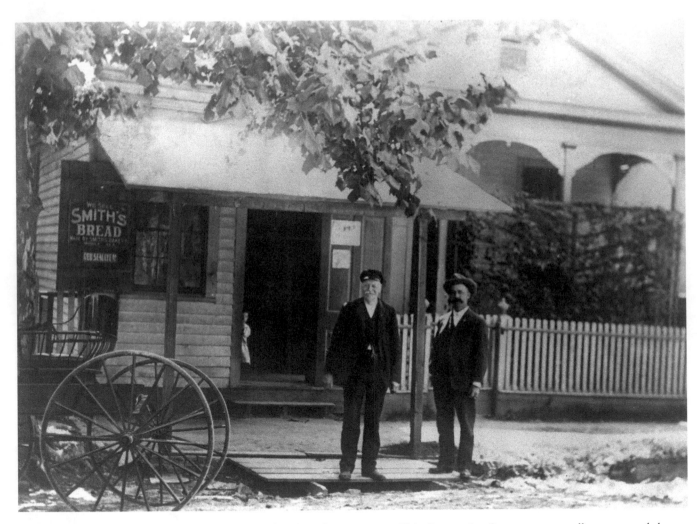

Smith's Bread has been available in Mobile stores for more than a century. This Conception Street store proudly announced they offered it for sale (ca. 1895).

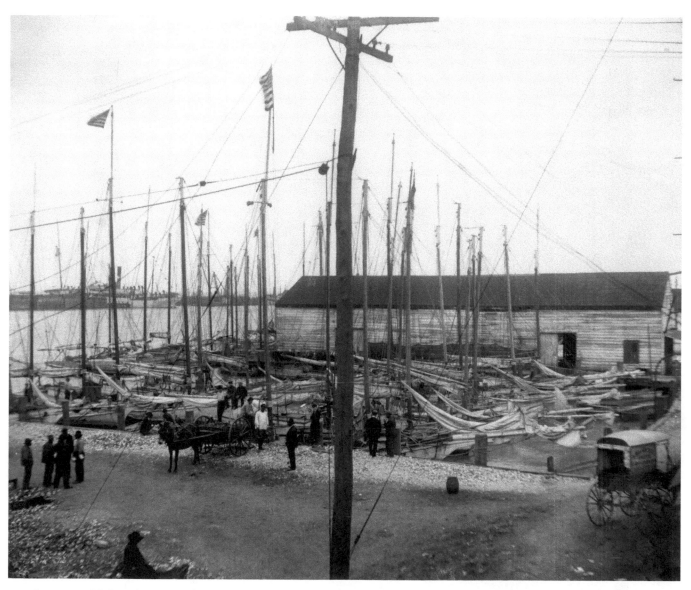

Commercial fishing has always been important to Mobile's economy, as this photograph of a fleet of oyster boats demonstrates (ca. 1895).

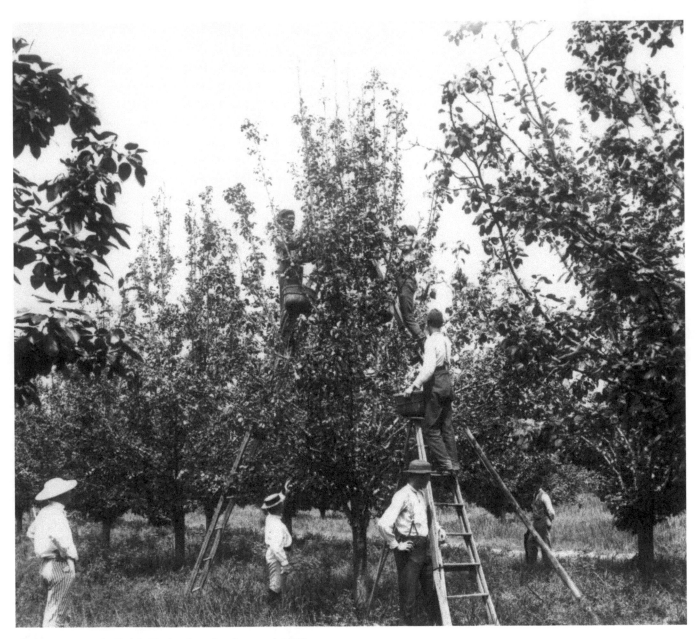

Gathering pears in E. M. Hudson's orchard around 1895.

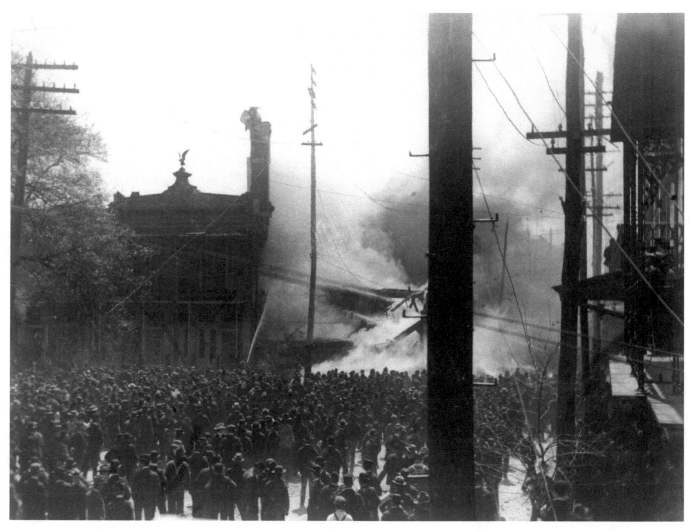

Mobilians watch as the Gayfer's building on Dauphin Street burns in 1899. Fires devastated many antebellum structures in the late nineteenth and early twentieth centuries.

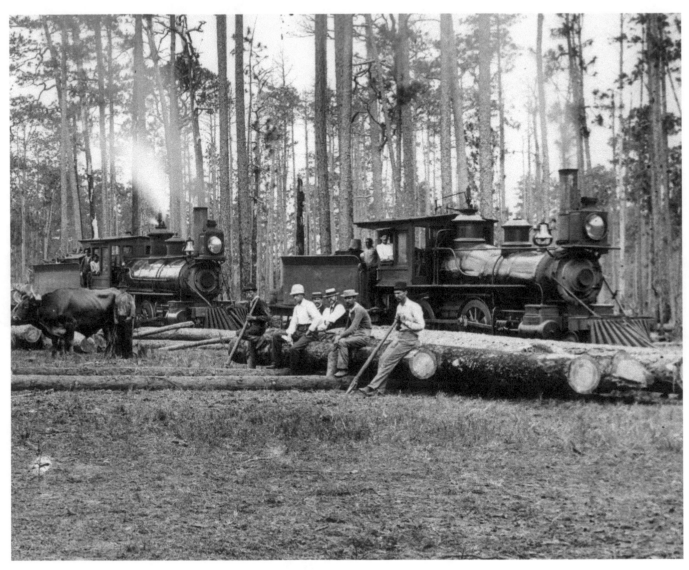

This image depicts some of the forces that drove the area's economy before the twentieth century—cattle, timber, and railroads.

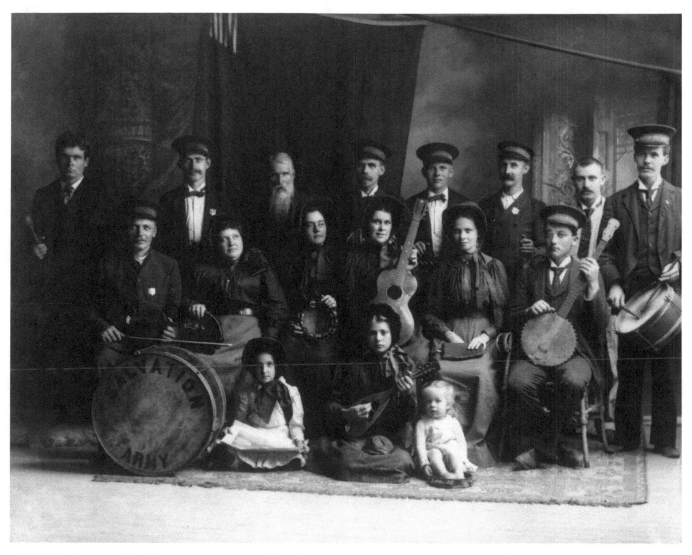

Mobile's chapter of the Salvation Army was established in October 1899 under the direction of Captain James T. Cumbie. Here, its band poses for a portrait in the studio of photographer Erik Overbey.

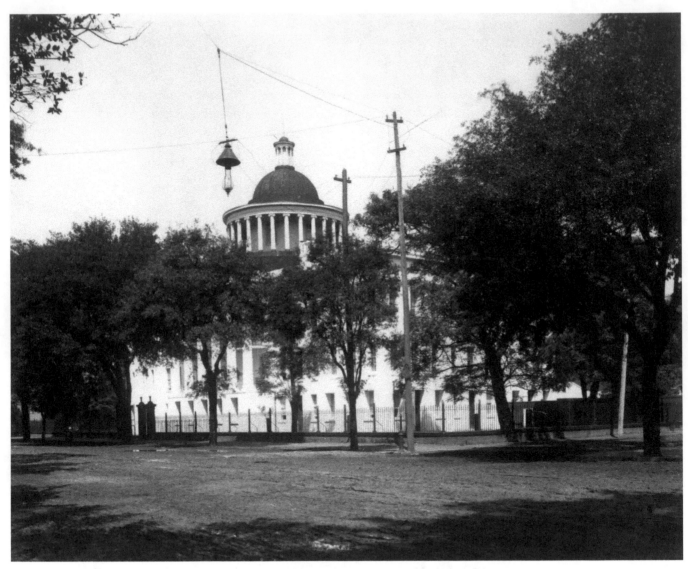

Barton Academy was Alabama's first public school. Built in 1835, it was named for state representative Willoughby Barton, the author of the bill creating Mobile's public school system. The building was used as a hospital for Union soldiers in 1864.

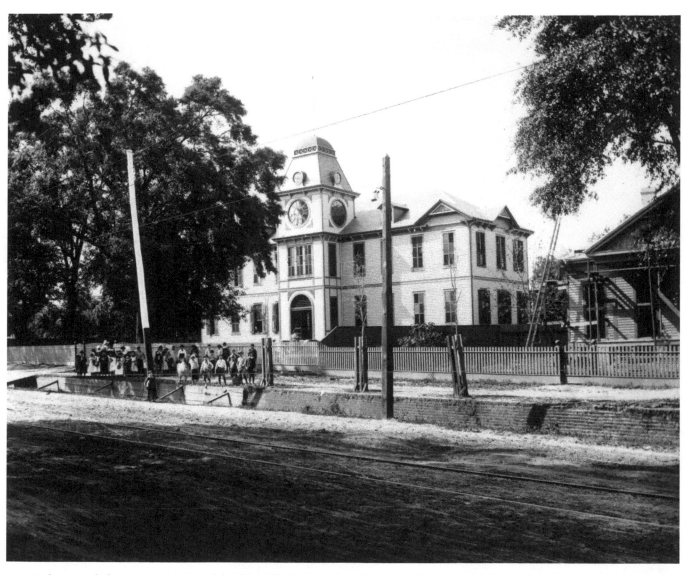

A photograph from around 1899 of the West Ward School, later known as the Admiral Semmes School. It stood on Springhill Avenue, just east of Ann Street, and was built in the Italianate style. It was torn down shortly after the First World War.

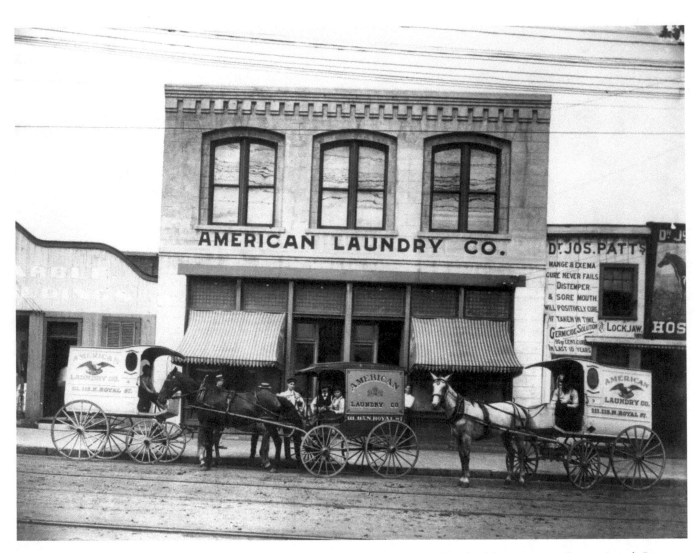

By the late nineteenth century, the American Laundry Company on Royal Street offered a delivery service. Doctor Joseph Patt, whose veterinary office was next door, would move his clinic to St. Michael and Joachim streets in 1908.

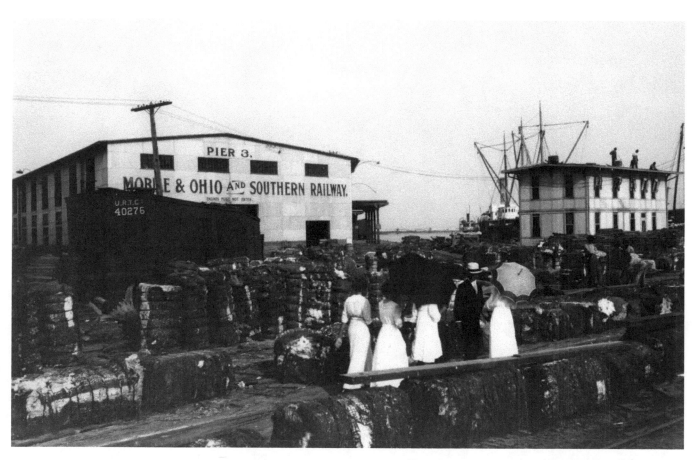

A man escorts four women on a tour of the Mobile & Ohio Docks.

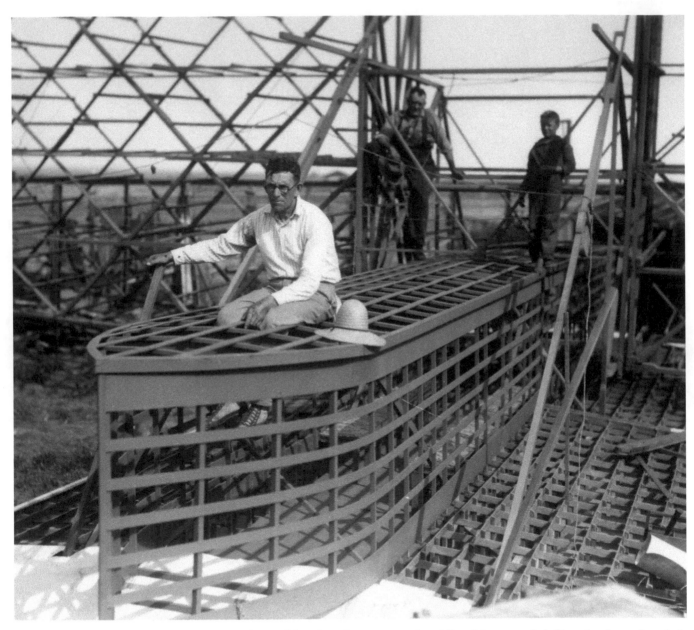

John Fowler, local inventor, sits at the front of one of the planes he constructed and flew. Many people believe that he perfected air flight before the Wright brothers.

Turn-of-the-Century Mobile

(1900–1919)

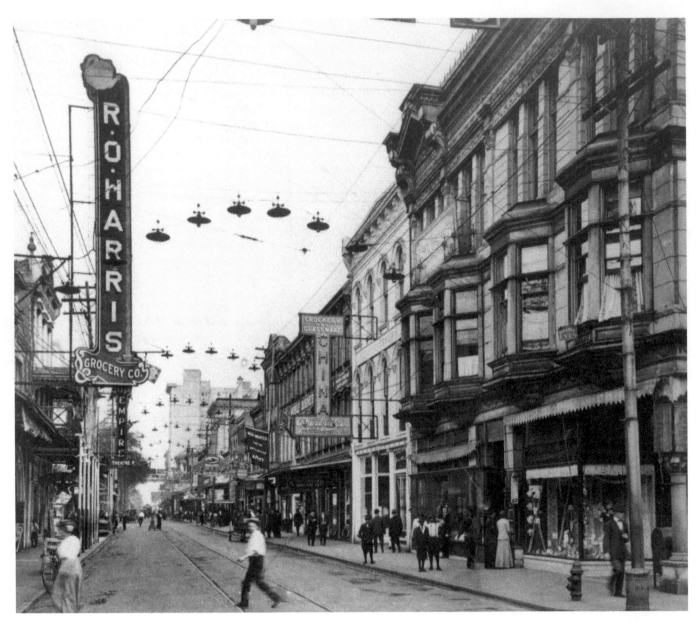

Dauphin Street, looking east from Joachim Street (ca. 1900). To the left are Harris Grocery and the Empire Theatre. A sign in the background reads, "Men Wanted for the United States Army."

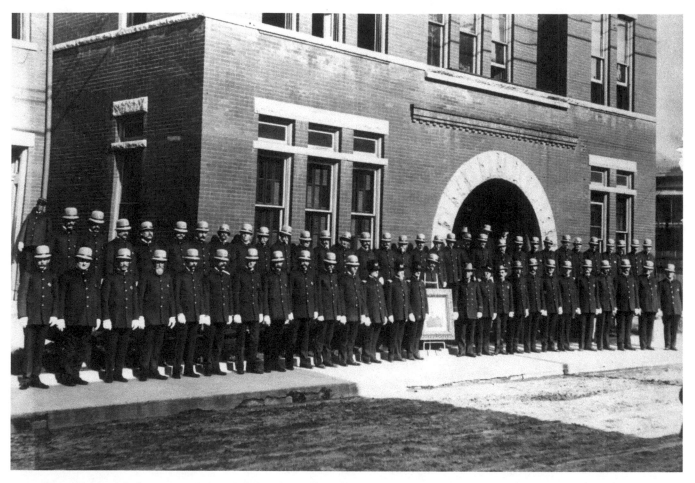

This photograph from 1901 shows Mobile police officers lined up in front of the police building on St. Emmanuel to honor Officer Edward McGrath Morris, pictured in the center. The 25-year veteran was mortally wounded March 31 while attempting to arrest two escaped convicts in a rail yard. He died the next day.

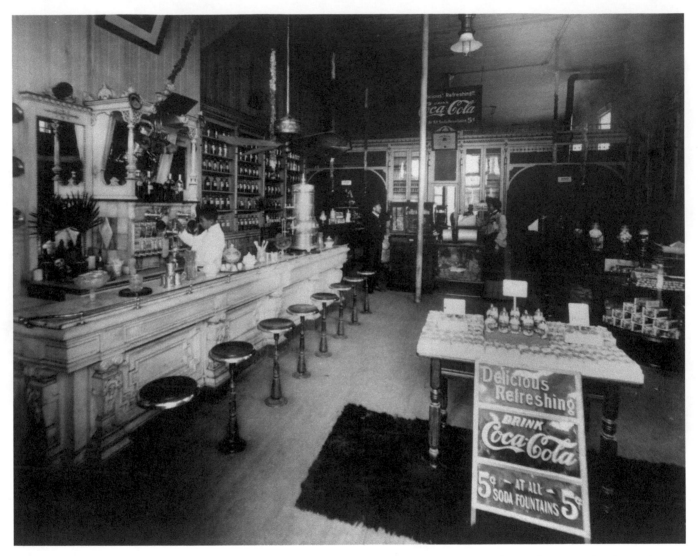

Owned and operated by African-Americans, People's Drugs, located at 522 Dauphin Street, offered a fine example of an early twentieth century drugstore and soda fountain.

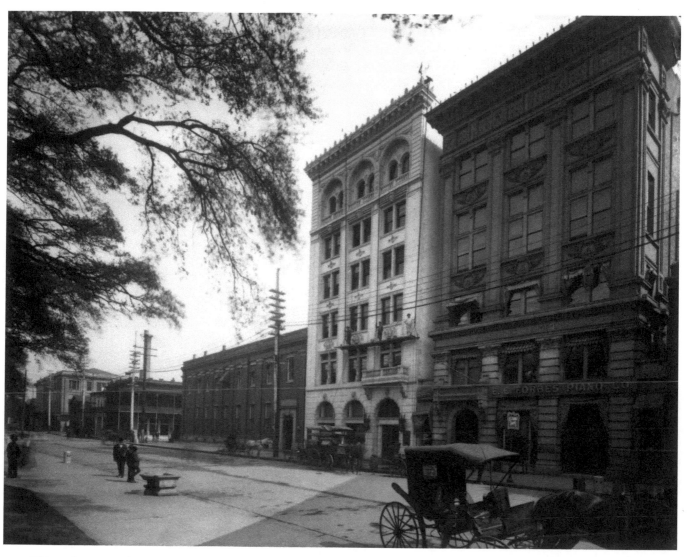

This early twentieth century photograph shows St. Joseph Street at Bienville Square, looking north. The building on the right was one of Mobile's first steel structures and housed the Forbes Piano Company. Attorneys William B. Inge and William H. Armbrecht, as well as various Masonic lodges, also occupied the building. Quartered in the two adjacent structures were, respectively, the City Bank and Trust and People's Bank.

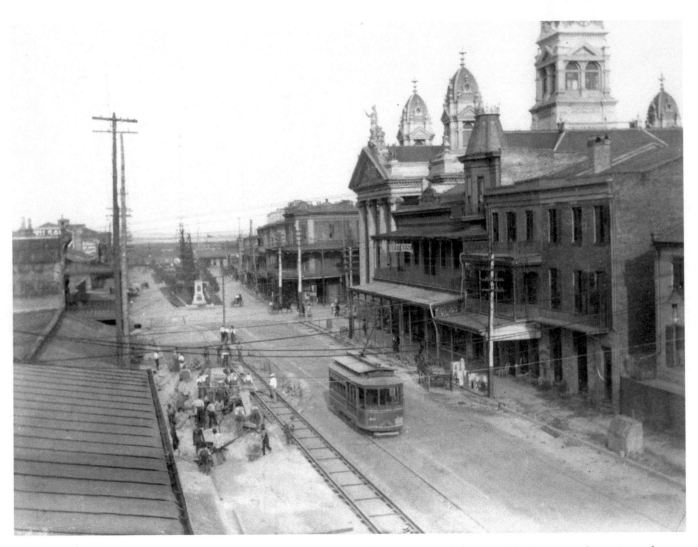

This September 16, 1904, photograph shows Government Street, looking east toward the river. The Benz courthouse is on the right. Two years after this image was taken, the 1906 hurricane struck and much of the building's statuary toppled. Next to the courthouse is Farley Brothers grocery store.

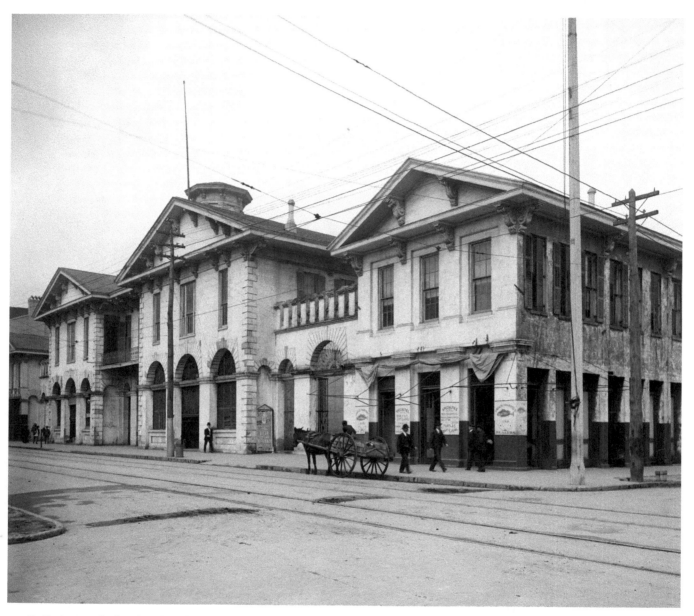

Built during the height of antebellum prosperity, the Mobile City Hall and Southern Market was a natural meeting place. City offices were on the top floor, and the bottom floor had large entryways with open rooms where vendors sold fresh fish, meats, produce, and a variety of other goods. Signs listed such specialties as red snapper, turtle, and catfish. The Museum of Mobile now occupies the building.

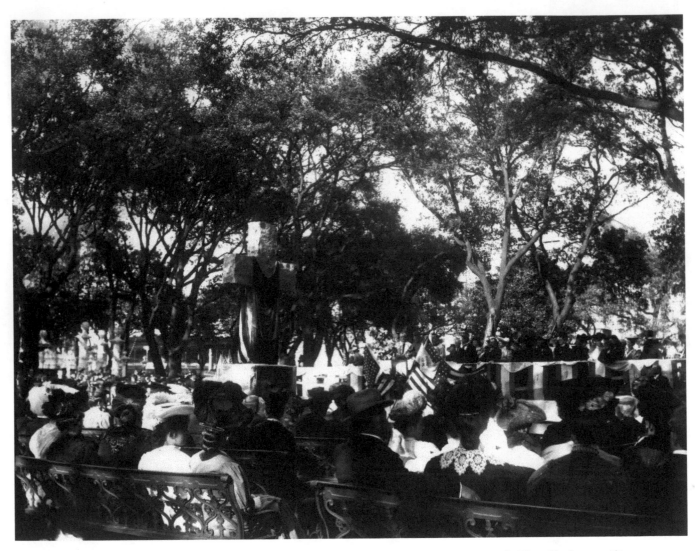

In 1906, Mobilians honored the founder of their city, French explorer Jean Baptiste Le Moyne de Bienville, by unveiling a monument to him in Bienville Square.

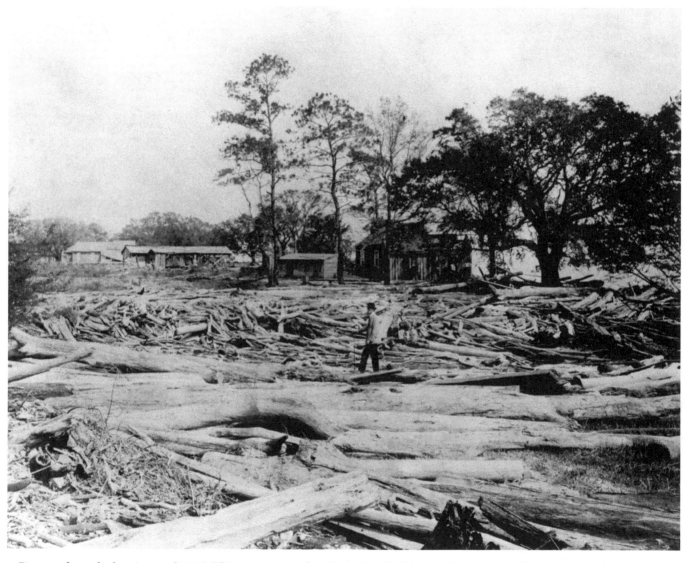

Damage from the hurricane of 1906. This structure used to sit on Bay Shell Road, along the waterfront just outside Mobile's city limits. The occupants had to flee for their lives in the midst of the storm.

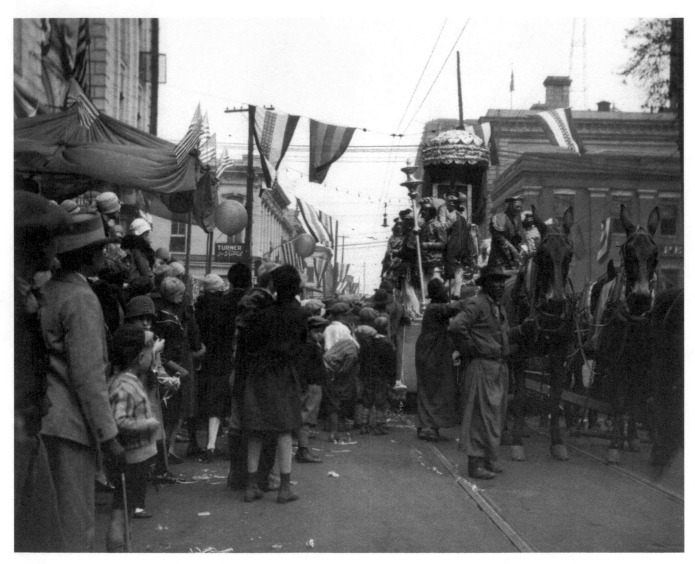

Riding on the King's float, members of one of Mobile's mystic societies throw candy and serpentine to eager children during this Mardi Gras parade on St. Louis Street.

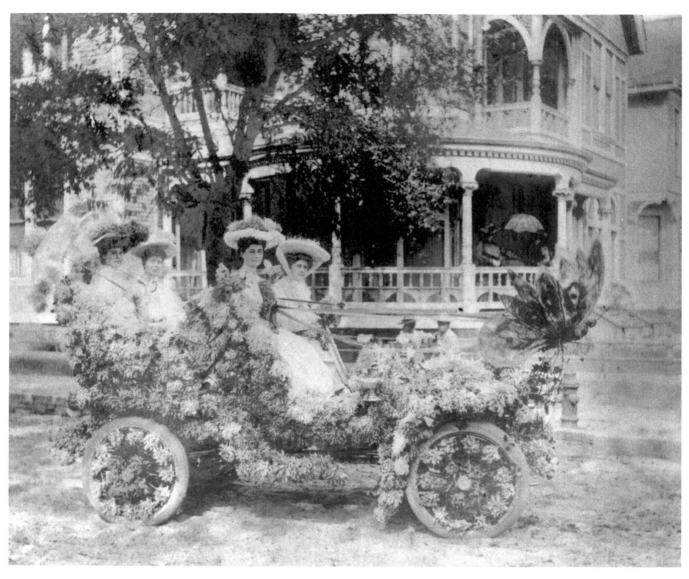

The Floral Parade became a regular part of the Mardi Gras celebration in 1929. Before that time, decorating a car with flowers was a popular way for Mobilians to take part in the festivities. This image was taken around 1910.

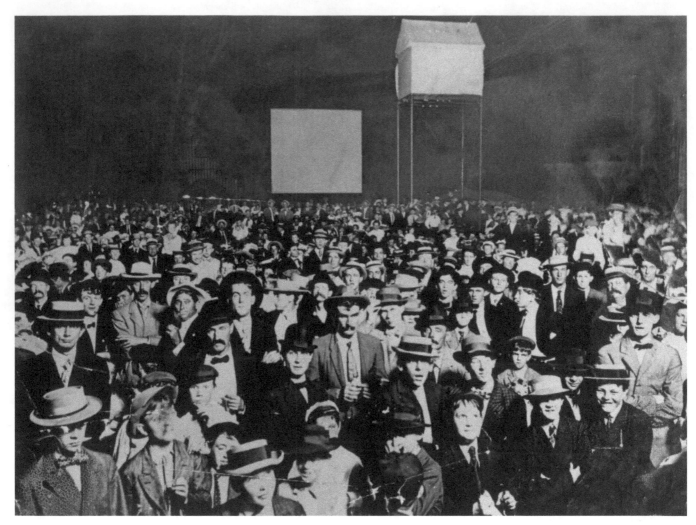

A crowd attends an event at the outdoor theater at Monroe Park around 1910. The park was destroyed in the hurricane of 1916.

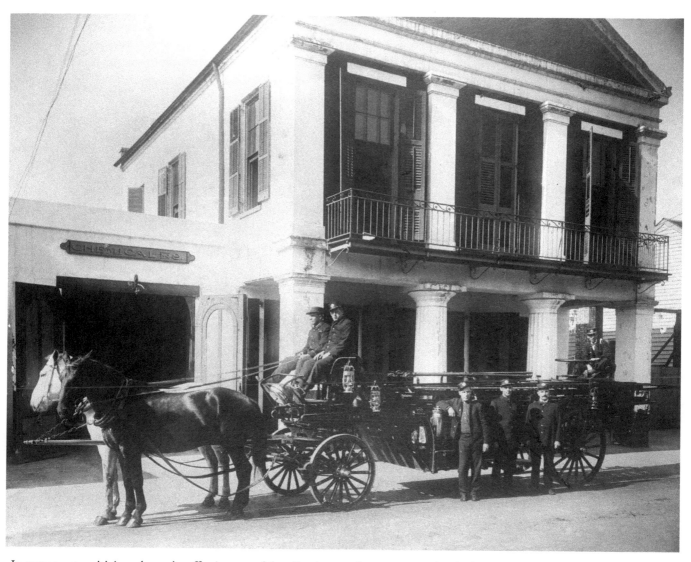

In response to criticism about the effectiveness of the all-volunteer fire companies that had spontaneously developed over Mobile's history, the city established a municipal fire department in September 1888. Here is the Washington Fire Engine Company, which was originally started in 1843. Their headquarters on North Lawrence Street was built in 1851.

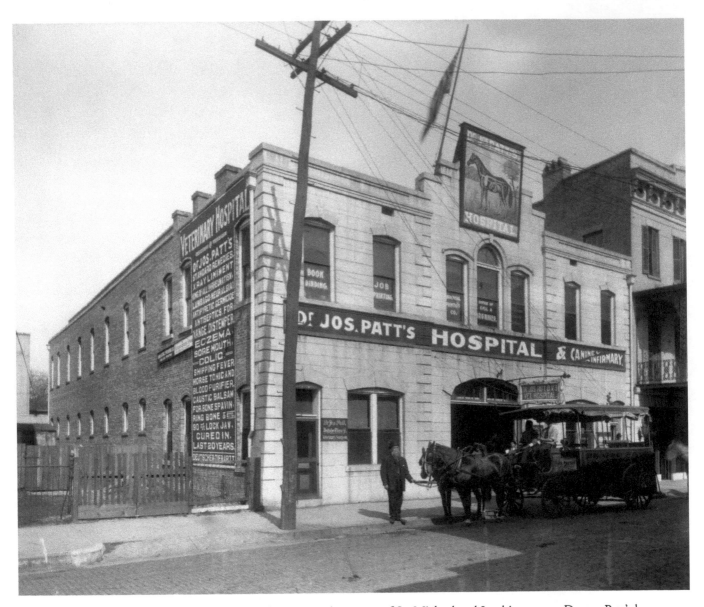

Doctor Joseph Patt's Veterinary Hospital, after relocating to the corner of St. Michael and Joachim streets. Doctor Patt's horse-drawn ambulance waits outside in case of an emergency. He claimed to be able to cure "rheumatism, lumbago, neuralgia . . . distemper, eczema . . . colic," and fevers of all sorts. E. A. Brunnier, a publisher, rented the second floor. By 1920, Patt's business succumbed to the advances of technology, and he went from treating horses to repairing automobiles. Ten years later, McKeen Motor Company purchased the building and undoubtedly removed the portrait of the horse.

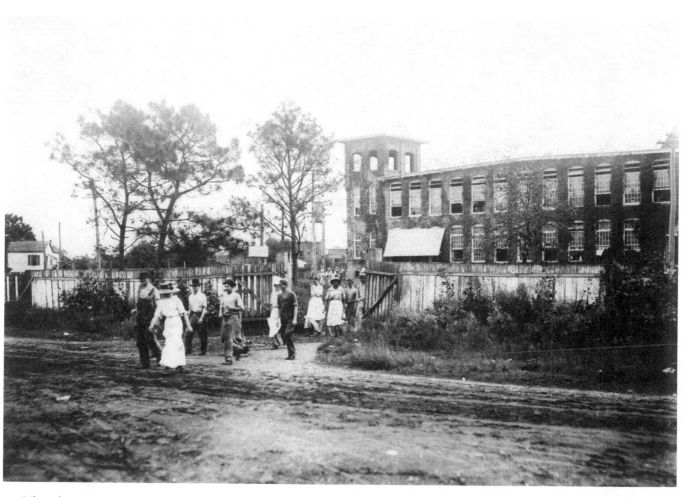

Like other cotton mills throughout the South, the Barker Mill near Mobile relied on women and children for much of its labor force. It was insular, having its own commissary and school. In October 1914, photographer Lewis Hine, a national crusader against child labor, visited the mill and concluded that the workers there were treated better than most in the South.

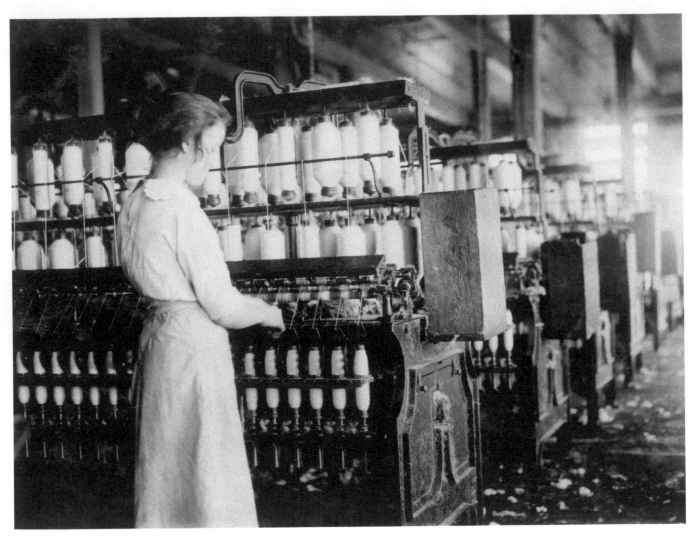

A young woman works the line inside the Barker Cotton Mill. Hine took this photograph to demonstrate working conditions inside the plant.

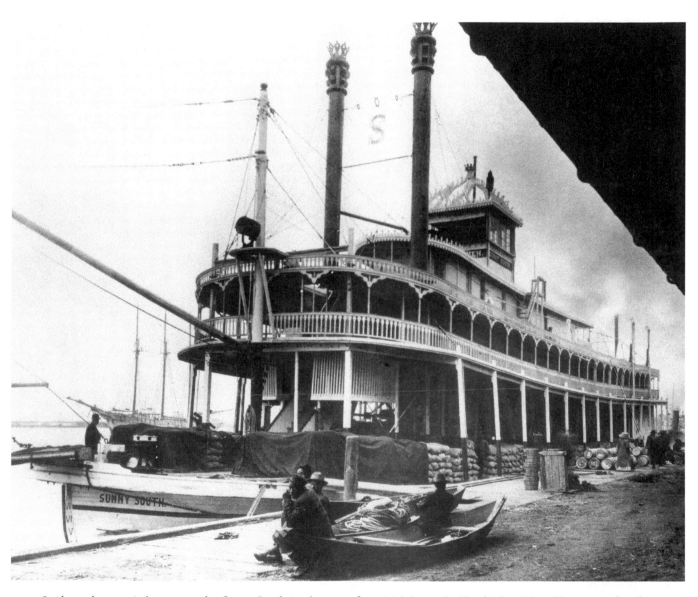

In the early twentieth century, the *Sunny South* riverboat ran from Mobile up the Tombigbee River. Two years after this 1914 photo was taken, she capsized in Mobile Bay.

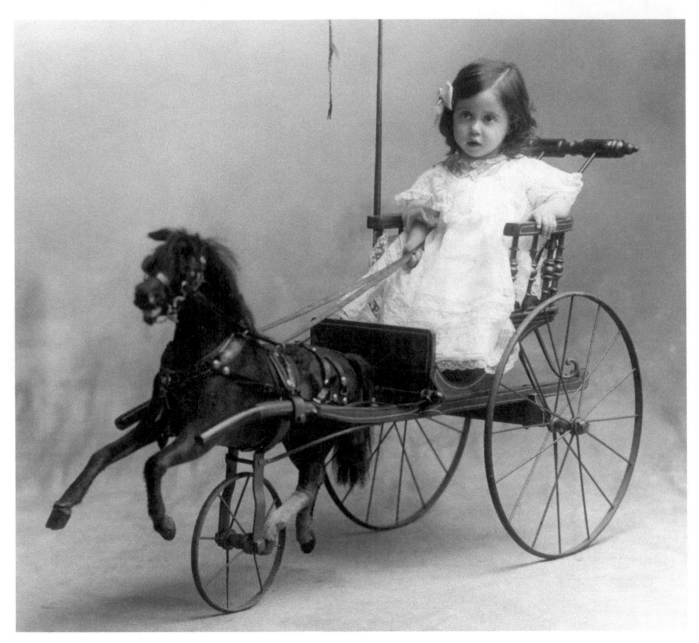

Today, photographers use all sorts of props in their portrait work, especially with children. That was no different in days gone by, as shown by this child sitting atop a toy horse and cart.

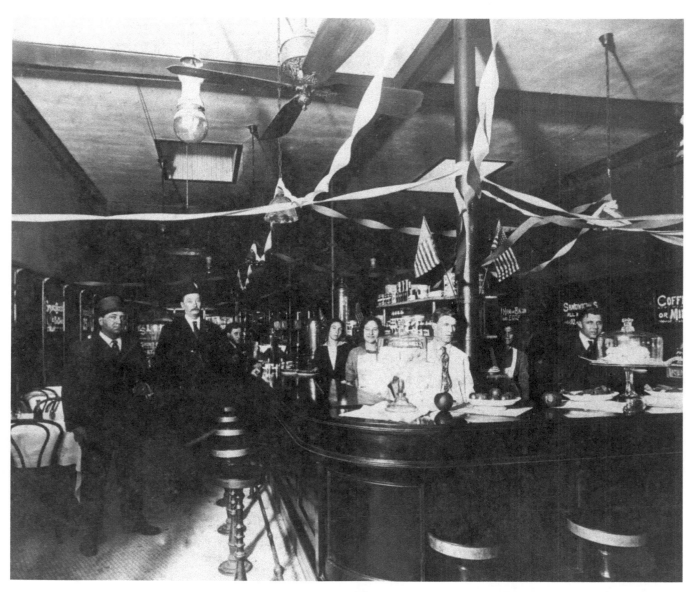

The interior of the Carlisle Café on South Royal Street in 1915.

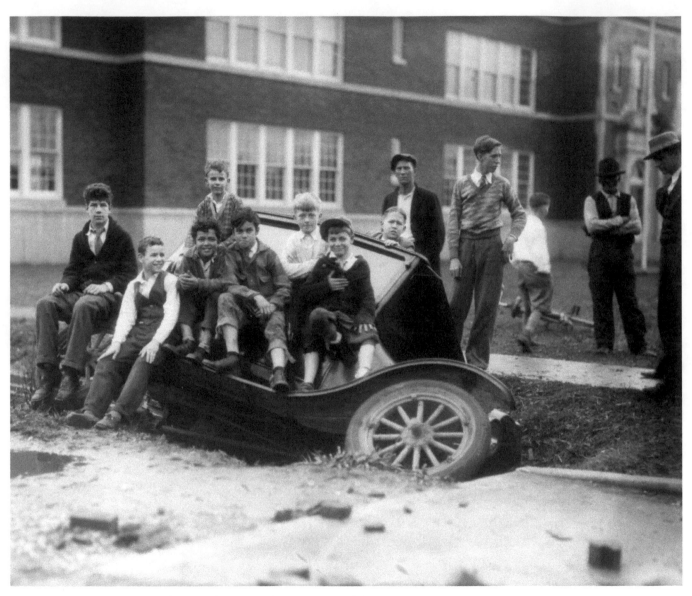

Children sit atop an overturned automobile, something quite novel for its time (ca. 1915).

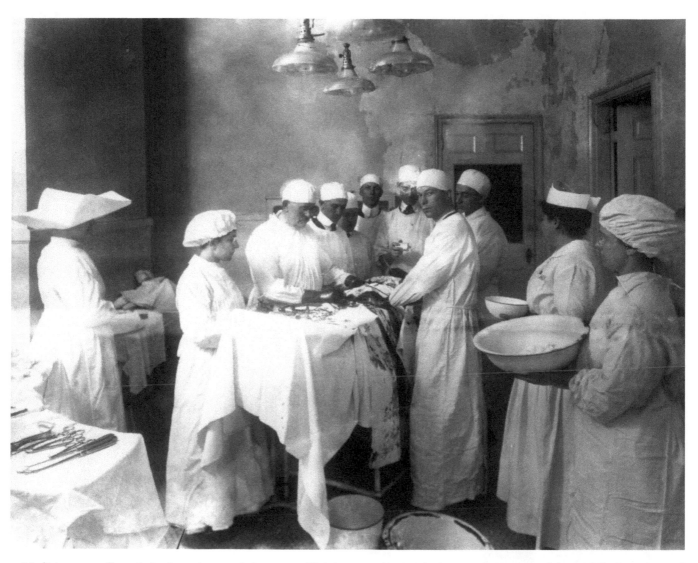

Medicine was still crude in the early twentieth century. This is a rare view inside the operating room of the Mobile City Hospital during a procedure in 1915.

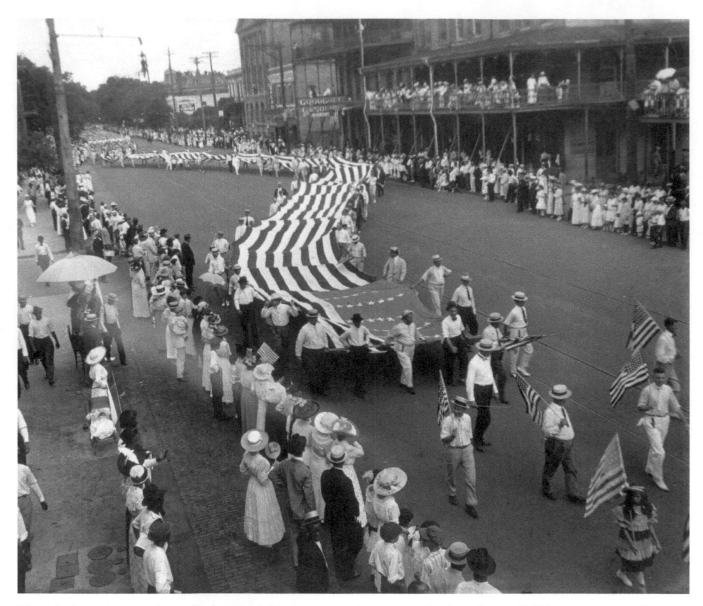

This July 4, 1916, preparedness rally down Mobile's Government Street was said to have shown off the longest American flag in history. Unbeknownst to these celebrants, a hurricane would hit the city the next day.

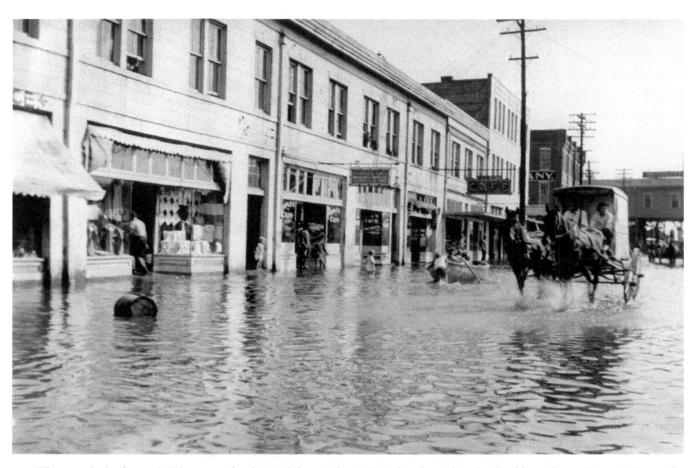

The next day's aftermath. The storm that hit Mobile on July 5, 1916, first formed in the Caribbean Sea on June 29. It was the first storm of the Atlantic hurricane season. The gale skirted the coast of Honduras and made landfall in Gulfport, Mississippi, only 75 miles from Mobile. The powerful rains and winds from the storm flooded streets and damaged businesses near Mobile's waterfront.

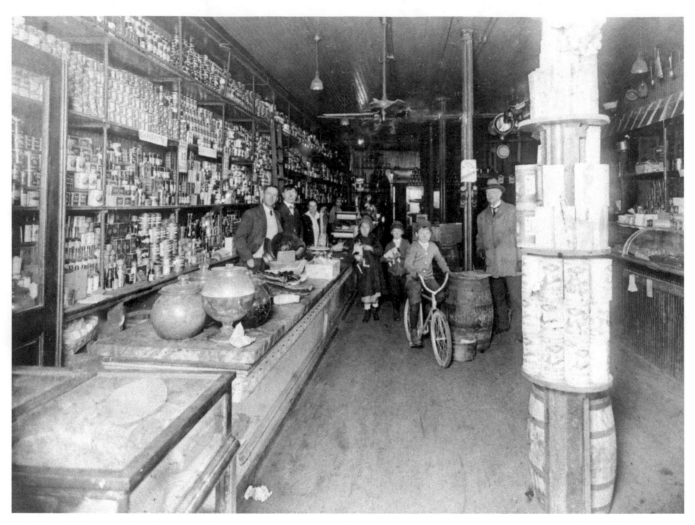

Members of the Meyer family pose in their grocery store on Dauphin Street in 1918. At that time, the store offered full service. Customers gave the clerk a grocery list, and he or she gathered all the items together. The store was located at Dauphin and Scott streets. Henry C. Meyer and his family lived on the top floor of the building and offered several rooms on the second floor for rent. Four murals covered the outside of the building, enticing passersby to come inside and shop. Twelve years after this photo was taken, the store was remodeled for self-service, reflecting the further commercialization of industry in Mobile.

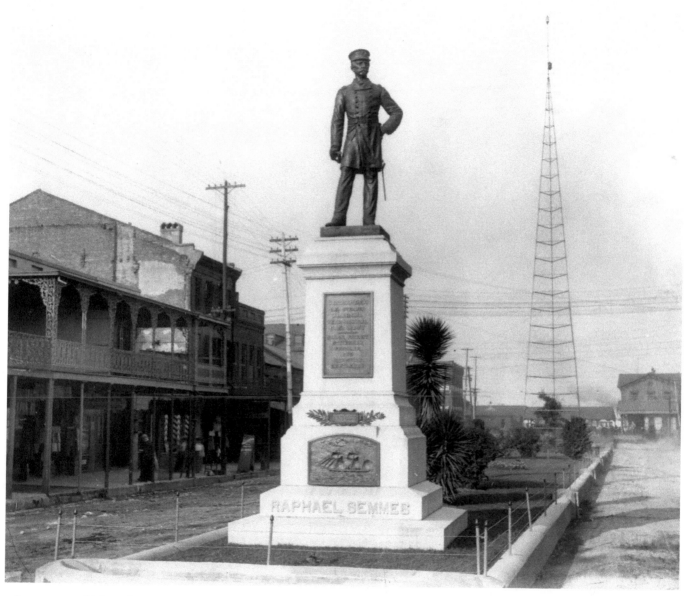

In memory of Admiral Raphael Semmes, captain of the CSS *Alabama* during the Civil War, Mobilians dedicated this monument in 1900. Semmes had been noted for his ability to harass Union shipping. His war service included being wounded and having his ship sunk by the USS *Kearsarge* in a duel off the coast of France in 1864. After the war he worked as a teacher and newspaper editor, later moving to Mobile to pursue a career as an attorney. He died in Mobile in 1877.

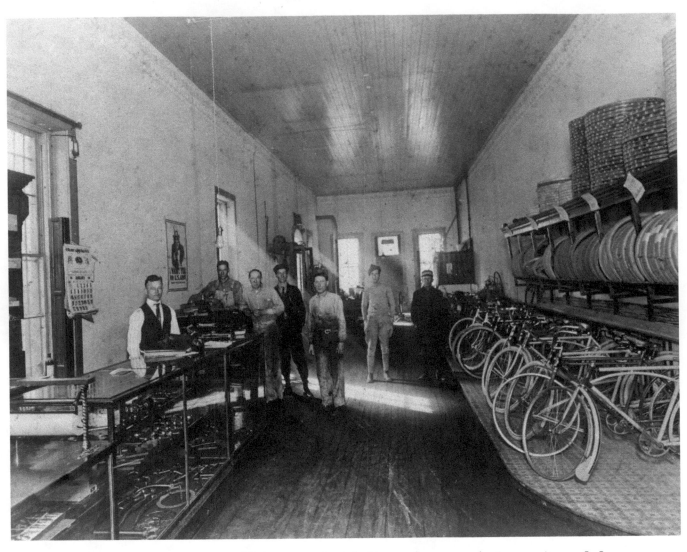

The Gulf City bicycle shop in January 1918. Their grease-stained clothing renders two mechanics conspicuous. In James Montgomery Flagg's famous war poster, on the wall at left, Uncle Sam recruits Americans for military service.

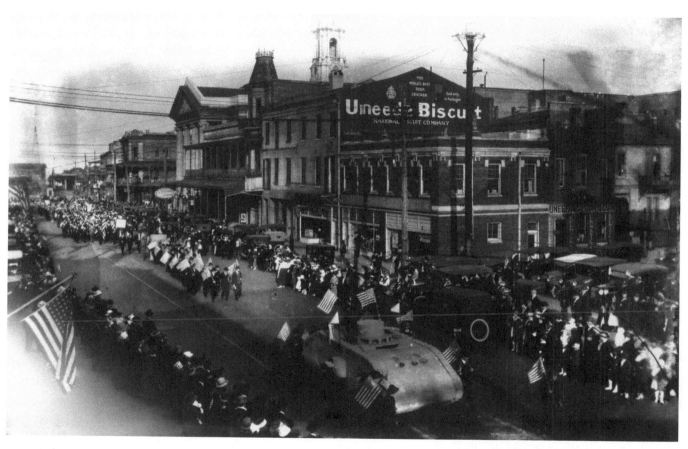

When America entered World War I, Mobilians supported the effort with several well-attended bond rallies, like this one on Government Street in 1918.

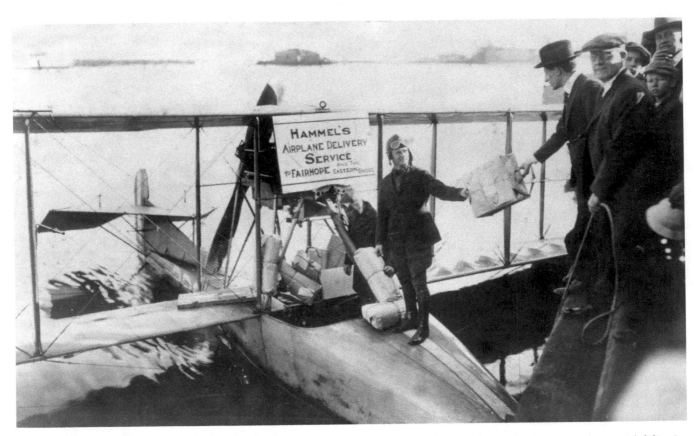

With no bridge to get across Mobile Bay, Hammel's Department Store improvised, using this hydroplane to make special deliveries in 1919.

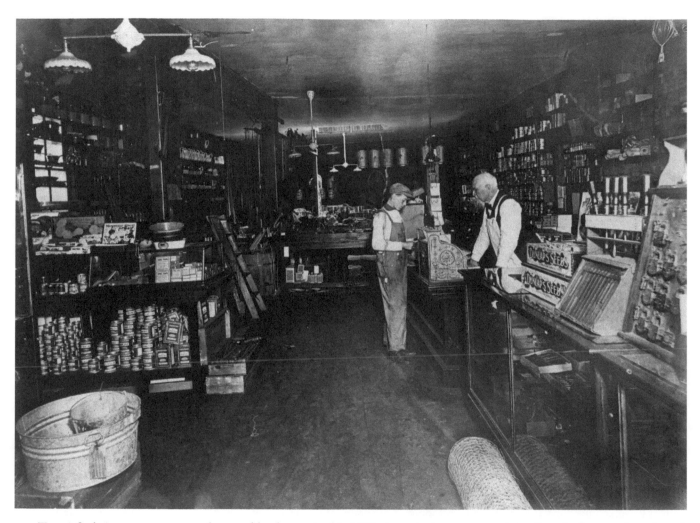

To satisfy their customers, general stores, like the one in this 1919 photo, had to carry a variety of goods, from seeds and spark plugs to crockery, galvanized buckets, and tire tape.

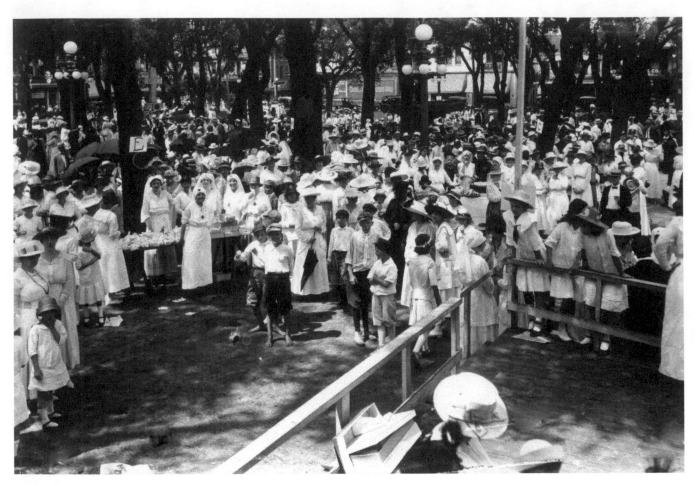

So many people filled the streets of downtown Mobile to celebrate the official end of World War I after the signing of the Versailles Treaty in June 1919 that the Red Cross had to set up an aid station in Bienville Square.

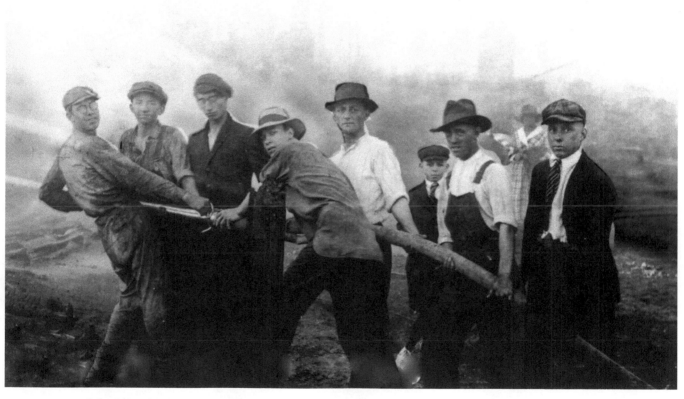

Fire fighters battle a blaze in Mobile in 1919. Remnants of burned downtown buildings can be seen in the background.

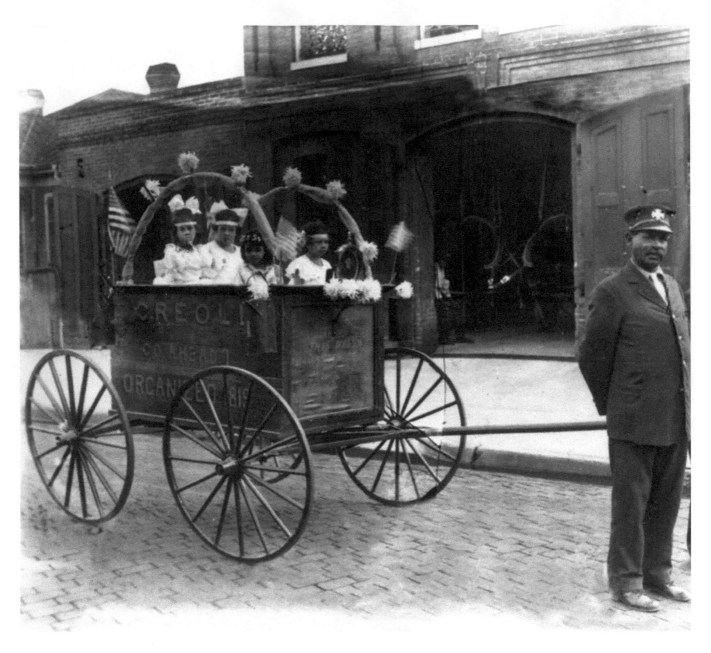

During the 1919 Mardi Gras season, these members of the Creole Fire Department and their families also celebrated their 100th anniversary by dressing up and decorating, and marching in that year's parade.

The Roaring Twenties

(1920–1929)

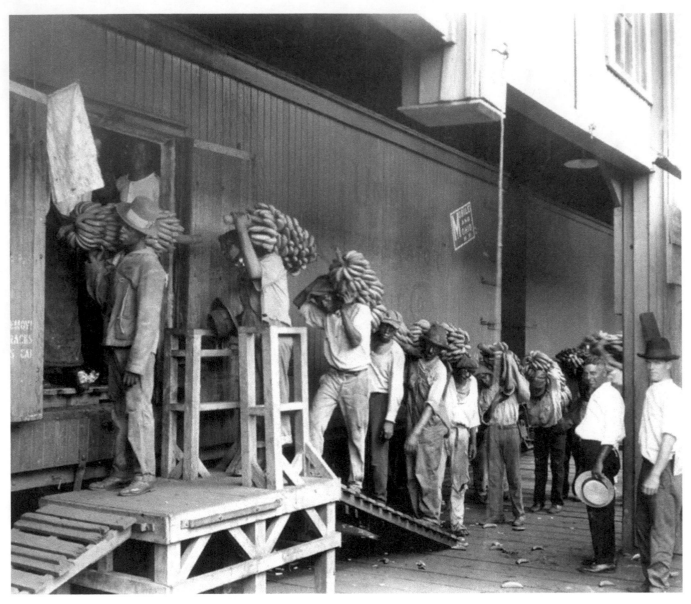

As the importance of cotton declined, the South American banana trade grew in significance. These African-Americans are loading bananas onto railroad cars.

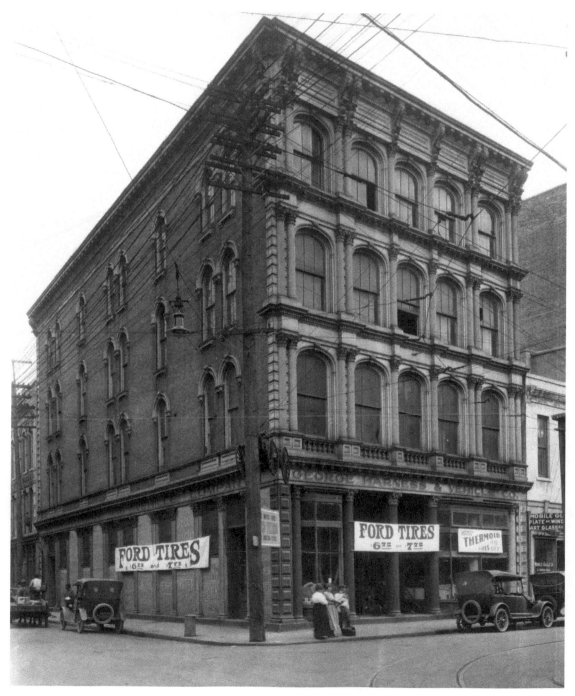

The George Harness & Vehicle Company building, located on the southwest corner of Dauphin and Water streets (ca. 1920), featured a cast-iron facade.

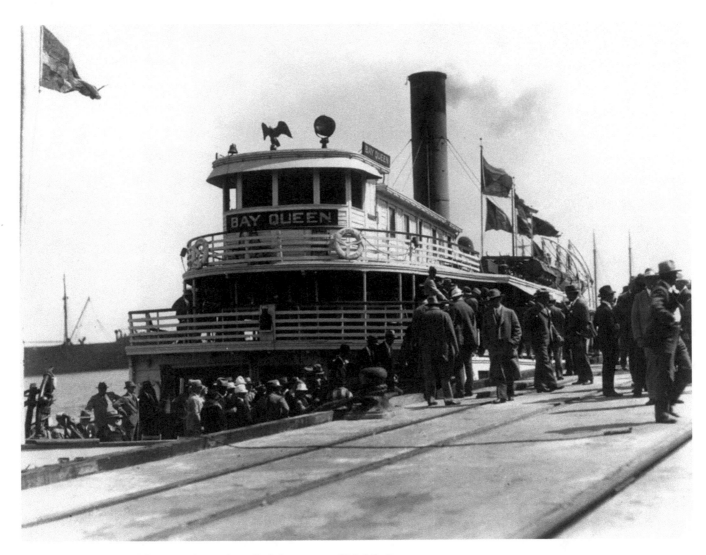

The *Bay Queen,* one of the many boats that plied the waters of Mobile Bay.

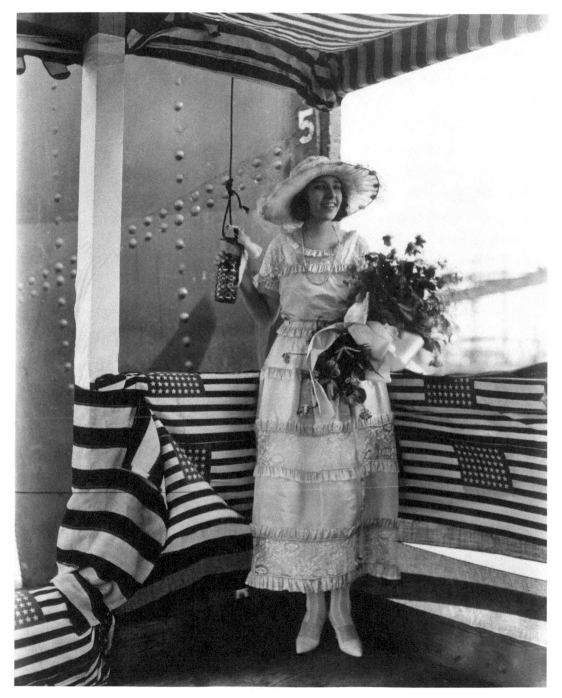

This young woman
prepares to christen the
City of Mobile at the
Chickasaw shipyard
in 1920.

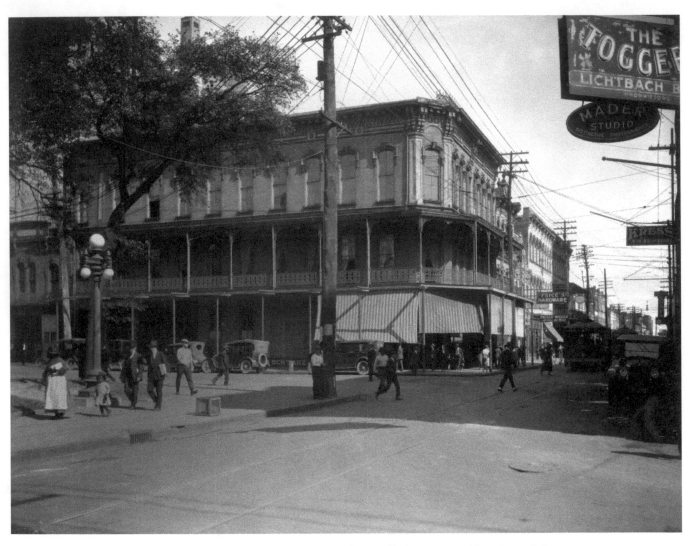

Dauphin Street at St. Joseph, looking east about 1920. A corner of Bienville Square is visible at lower-left.

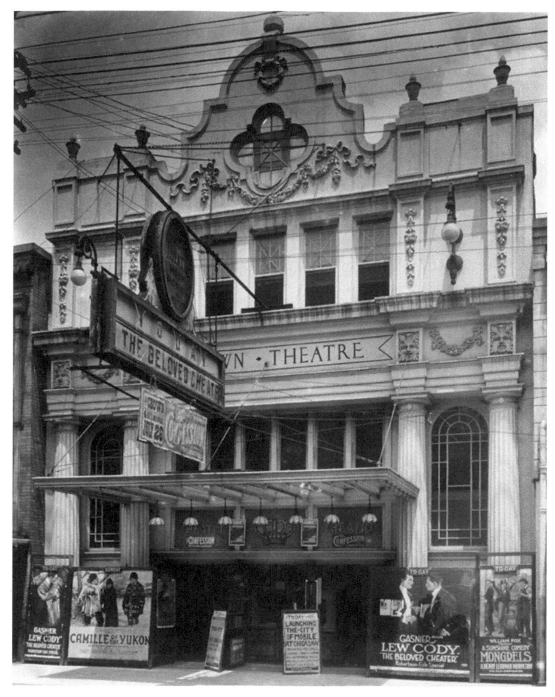

Mobilians could go to the Crown Theatre on Dauphin Street and watch footage of the *City of Mobile* launching from the Chickasaw shipyard, and, as the sign proclaims, an automobile parade and "other interesting scenes."

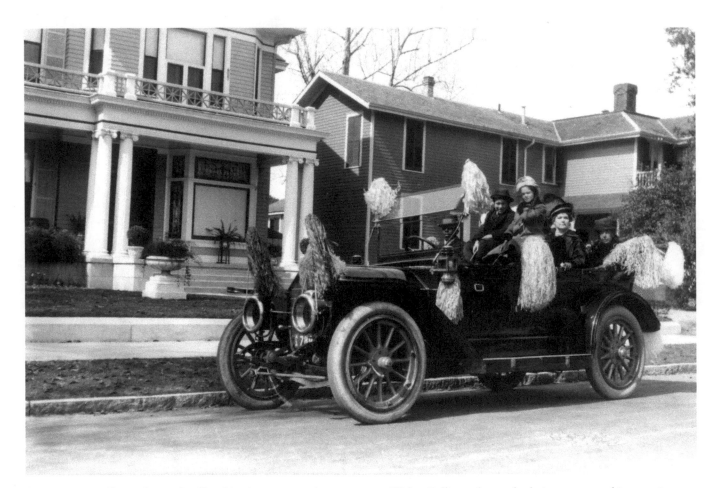

Bessie Morse Bellingrath—wife of local businessman and entrepreneur Walter Bellingrath—and relatives are seated in a car in front of their Ann Street home. Bellingrath's niece Alice Sackhoff (wearing the white hat) is seated behind her.

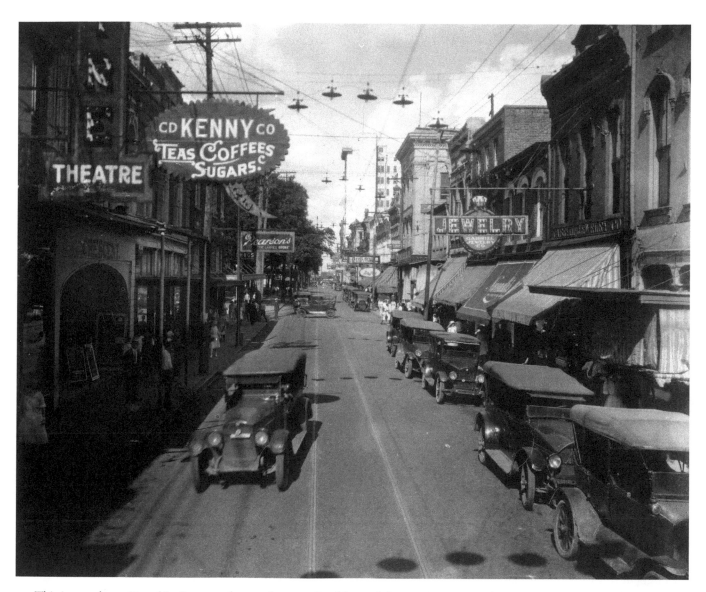

This image shows Dauphin Street to the east, between Joachim and Conception streets, about 1922. It was once the city's retail center. Farther down the street, on the right, were at least three shoe stores, including Simon's Shoes and Level Best Shoe Store.

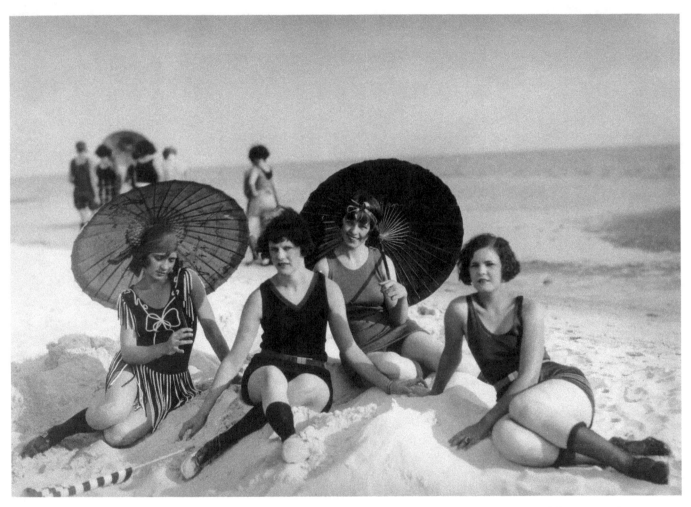

Eric Overbey was Mobile's preeminent photographer and captured images not only of the city but also of the surrounding area, including these 1923 beauty pageant contestants on Biloxi Beach.

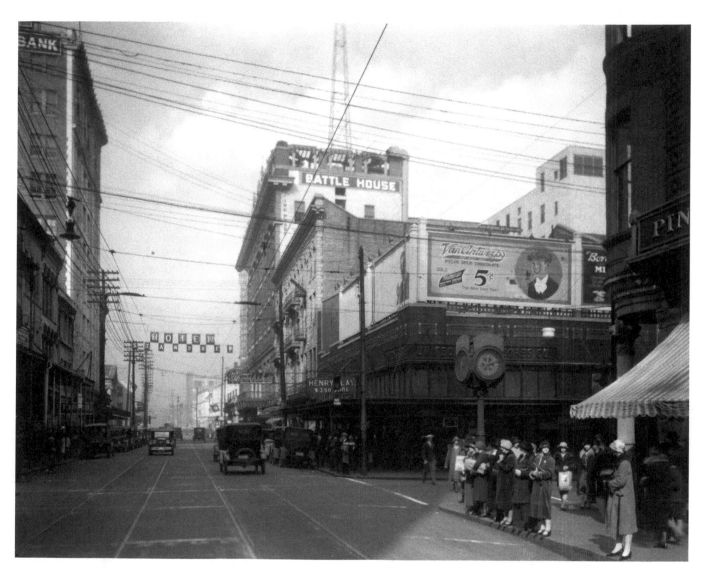

Royal Street at Conti, looking north (ca. 1925).

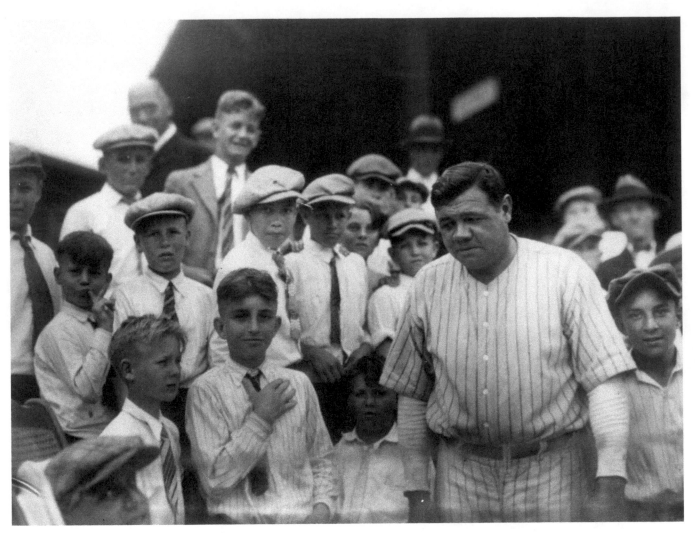

Babe Ruth and the New York Yankees came to Mobile several times in the 1920s to play exhibition games. Here, the "Sultan of Swat" meets some of his younger fans. An orphan himself, Ruth usually took time out of his schedule to visit the local Catholic Boys Home.

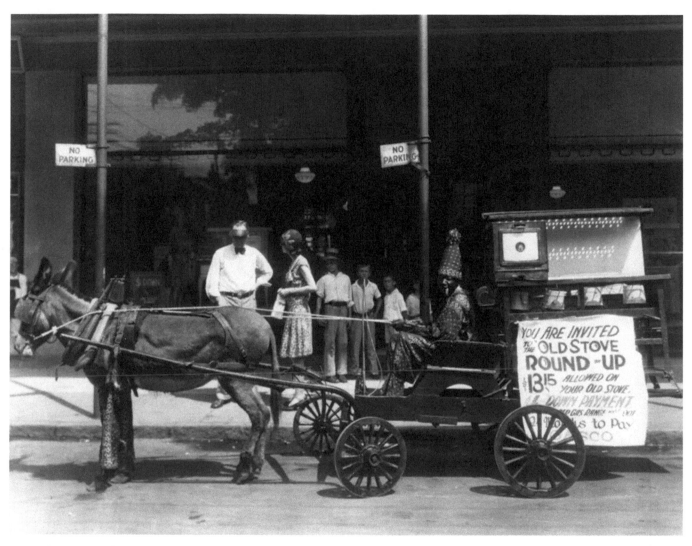

The annual "old stove round-up" was a promotional parade and sales event sponsored by the Mobile Gas Company. This one most likely took place in the 1920s. A clown driving a mule-drawn carriage draws a sign reading "You are invited to the Old Stove Round-Up. $13.15 allowed on your old stove. $1 down payment . . . 12 months to pay."

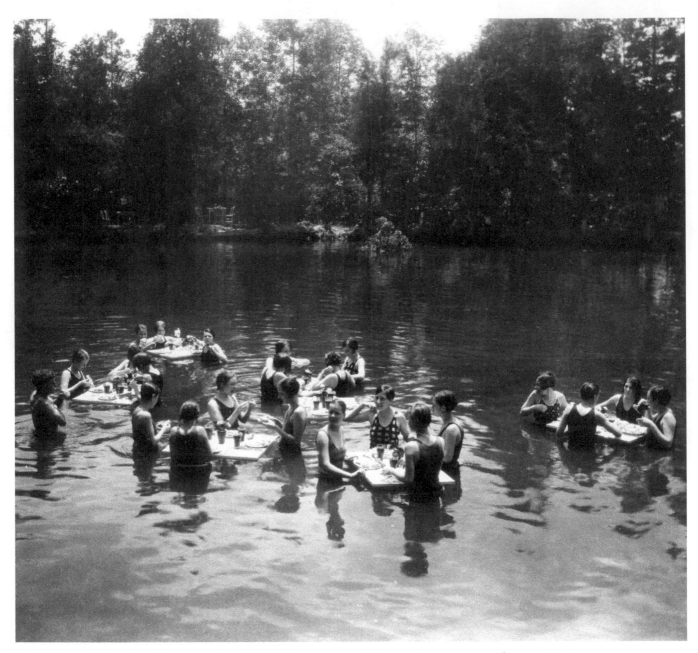

In 1926, people found creative ways to beat Mobile's hot summers. Why not throw a party at the same time?

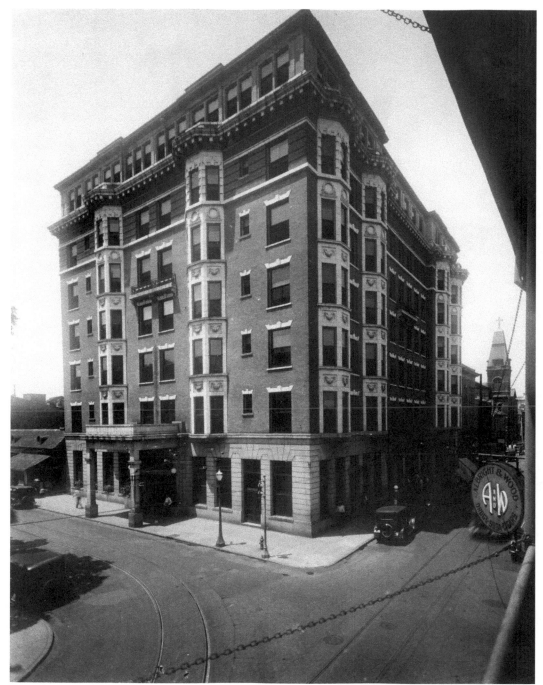

The Cawthon Hotel was built in 1906 using a steel frame and reinforced concrete. Atop the hotel was a glass-enclosed garden for dances and banquets. In 1927—about the time this image was taken—the celebrated evangelist Billy Sunday stayed at the hotel while holding a series of religious revivals.

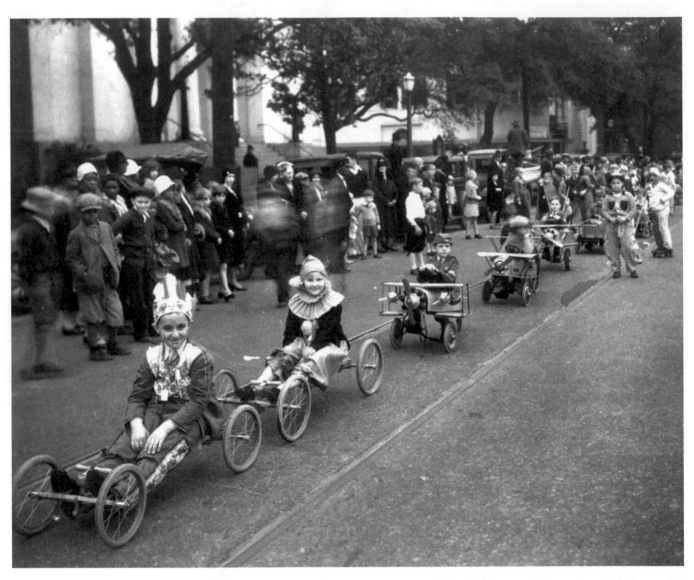

As a means of advertising and promotion, the Reiss Mercantile Company sponsored this holiday parade in 1927, which featured children riding the latest in toys.

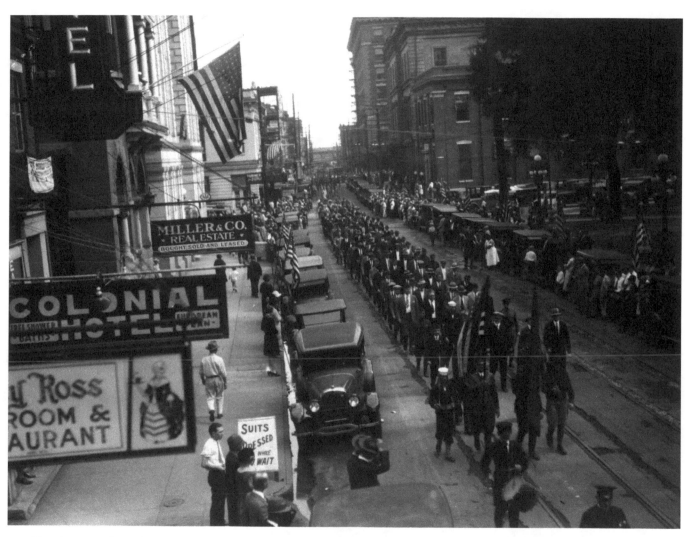

Marchers parade up St. Francis Street as a crowd looks on (ca. 1928). The reason for the procession is unclear, but it may have been a July 4th event featuring veterans of the Great War.

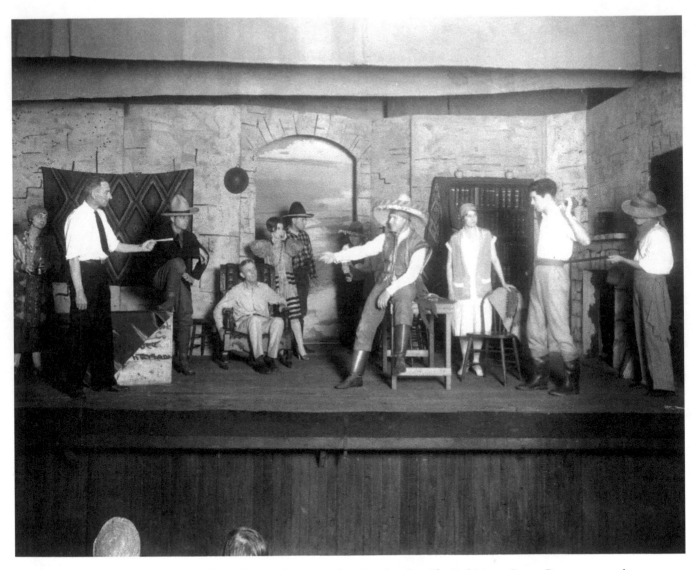

The Little Theatre, predecessor of the Joe Jefferson Players, performing the play *The Bad Man*, a Porter Browne story about a Mexican bandit.

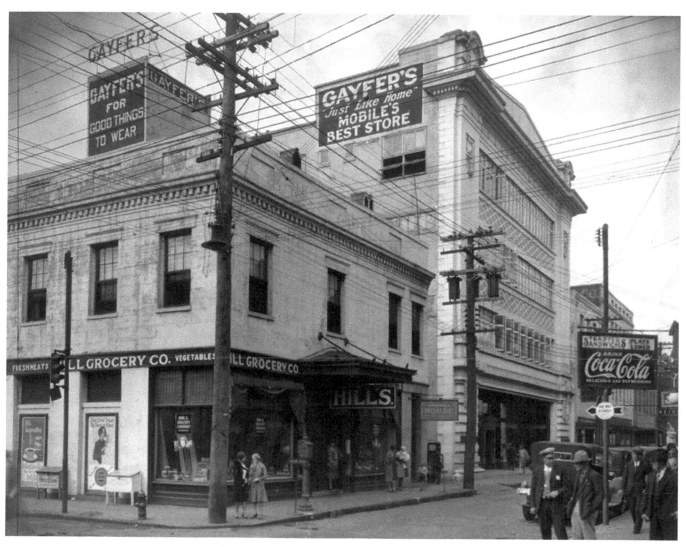

Saint Emanuel Street, looking north to Dauphin from Conti in 1929. Hill's Grocery Company is on the corner, just south of the homegrown Gayfer's Department Store.

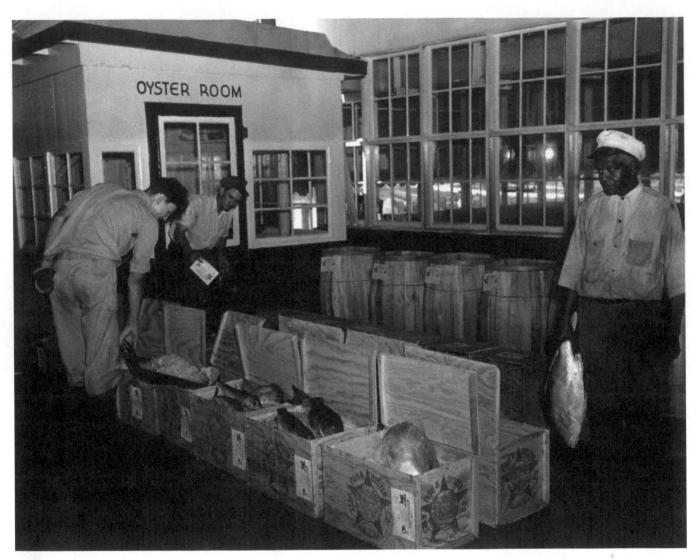

Men pack seafood with ice outside the Oyster Room at the Star Fish and Oyster Company about 1930. The company was founded in 1900 by Sebastian Gonzales and became one of the most successful commercial fishing concerns in the United States, running a fleet of schooners that brought in for sale each year hundreds of thousands of pounds of red snapper and other seafood.

New Deal Mobile

(1930–1939)

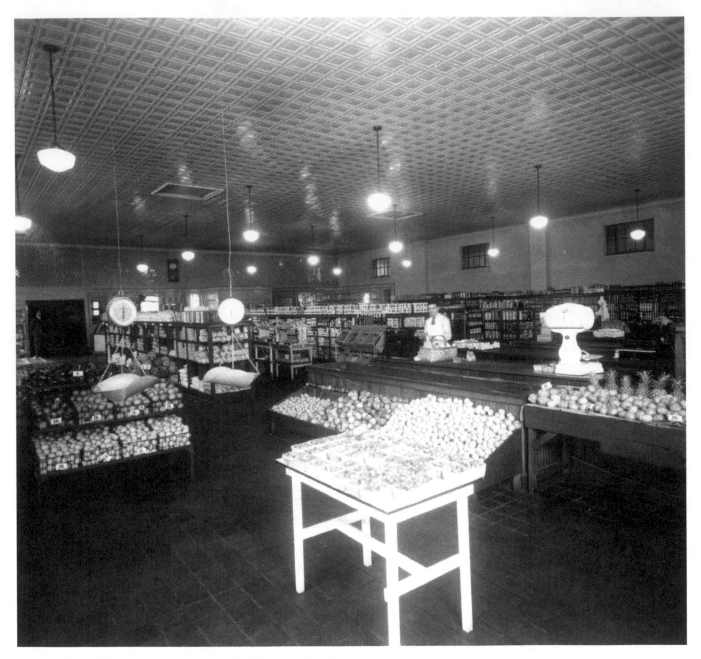

Interior of a Delchamp's Grocery Store in Mobile around 1930.

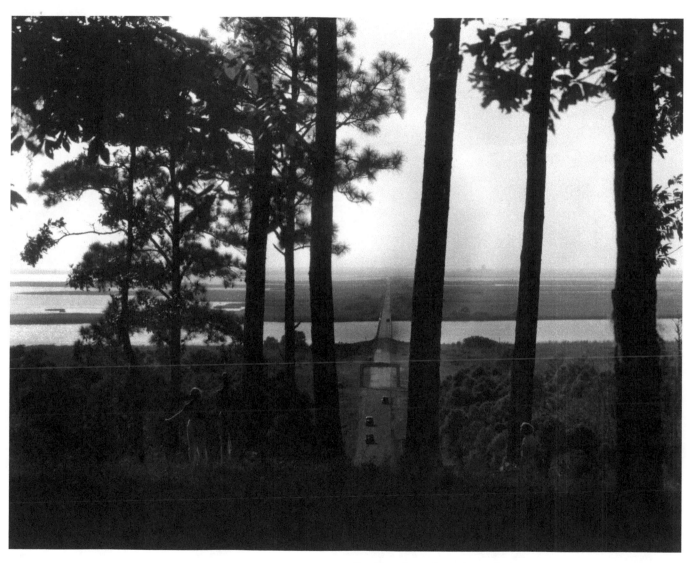

Looking down from Spanish Fort toward Mobile around 1930.

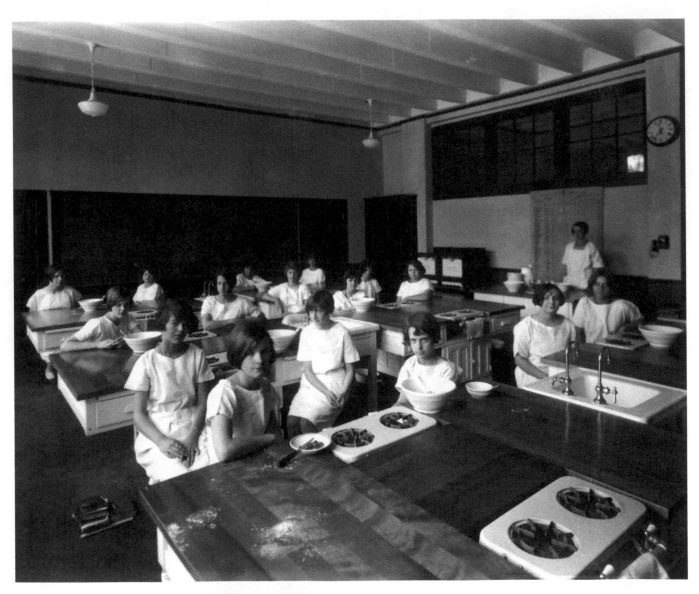

A home economics class at Mobile's Murphy High School.

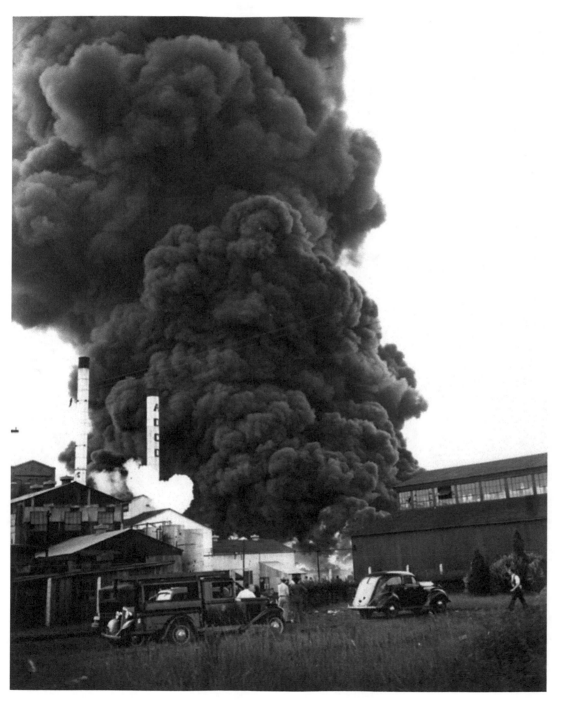

Thick, black smoke billows skyward as the Alabama Naval Store at South Water and Virginia streets burns.

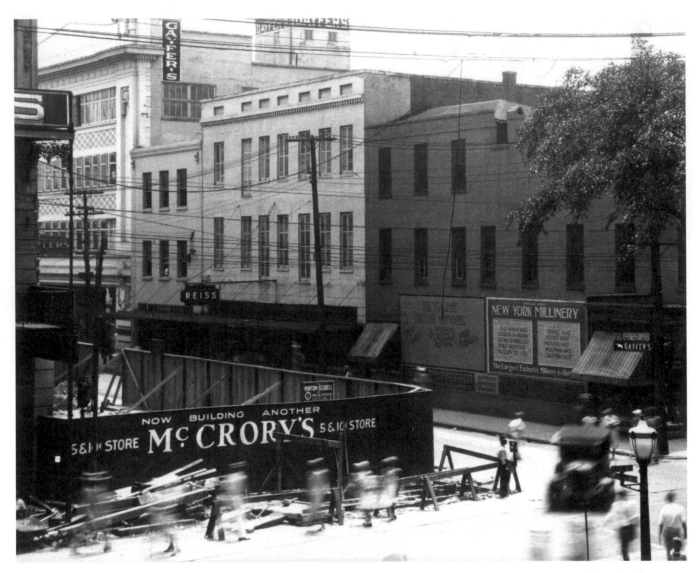

Saint Emanuel Street to the south, 1930, with a second McCrory's Five and Dime Store under construction and the "new" Gayfer's Department Store in the background.

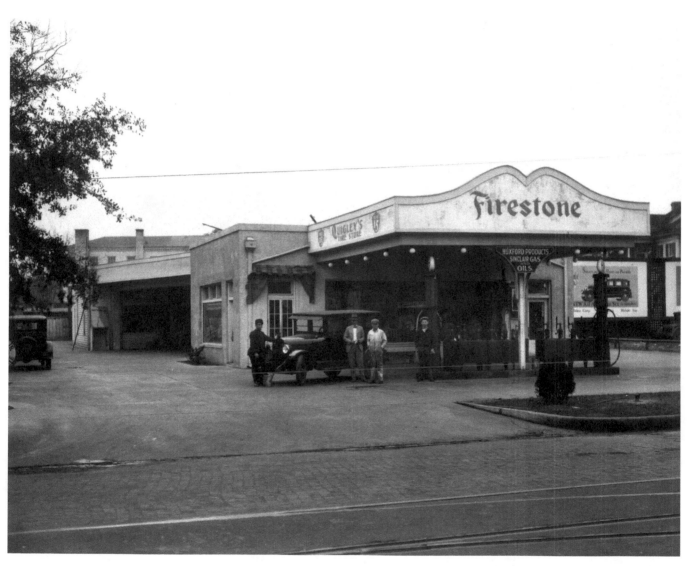

Huxford Oil Company's gas station on Broad Street in Mobile around 1930.

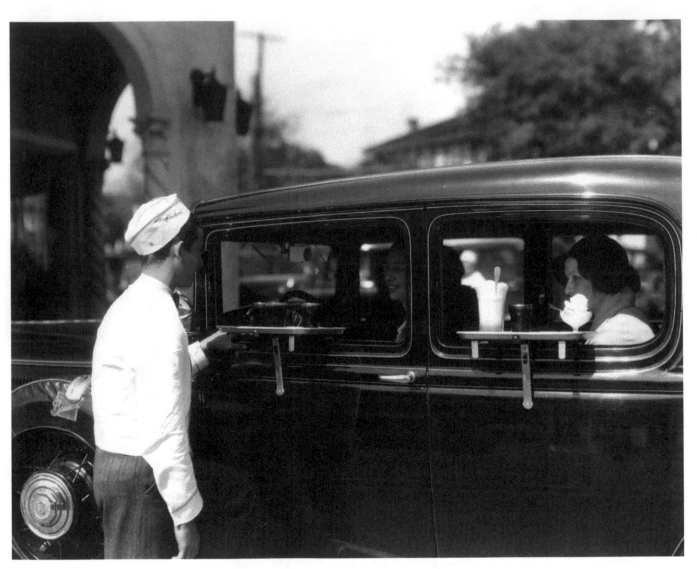

Two unidentified women enjoy refreshments served to them by an Albright and Wood carhop. Albright and Wood once had a chain of drug stores operating in Mobile. This image was taken in 1931.

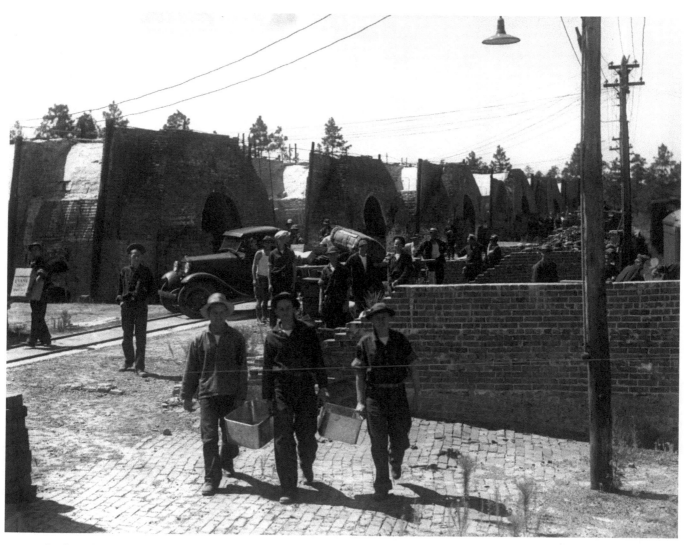

Civilian Conservation Corps workers load items into brick kilns at a brickyard somewhere between Kushla and Chunchula, Alabama, around 1933.

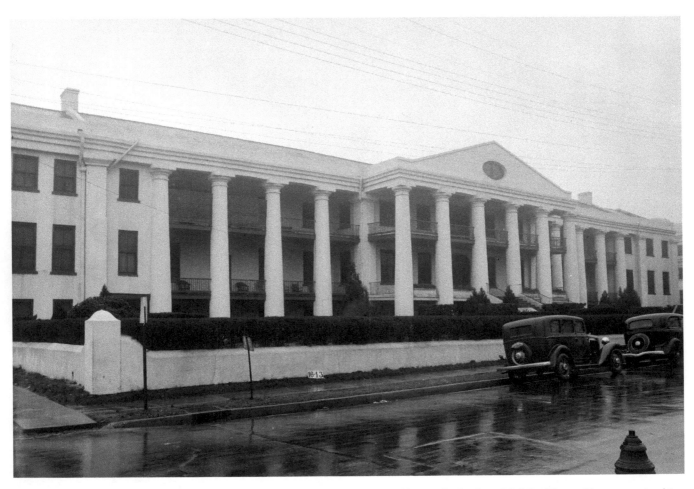

The old City Hospital, constructed in 1833, was the first Greek Revival building to be built in Mobile. The end bays, seen in this image from 1934, were not a feature of the original building. Today it houses the Mobile County Health Department.

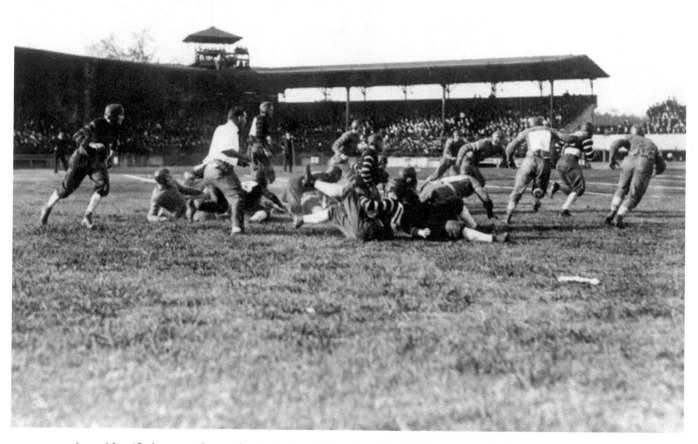

An unidentified group of men play football in the 1930s at the old Hartwell Field, which was located at Tennessee and Ann streets.

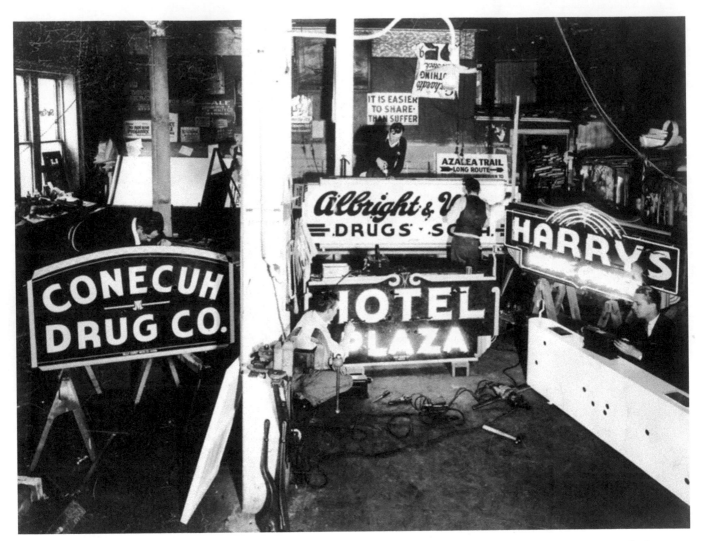

The interior of the Gulf Coast Sign Company, showing workers creating signs for the Conecuh Drug Company, Harry's, the Hotel Plaza, and Albright and Wood Drug Store (ca. 1935). One sign in the background reads, "It is easier to share—than suffer." Another says, "Do not use profanity."

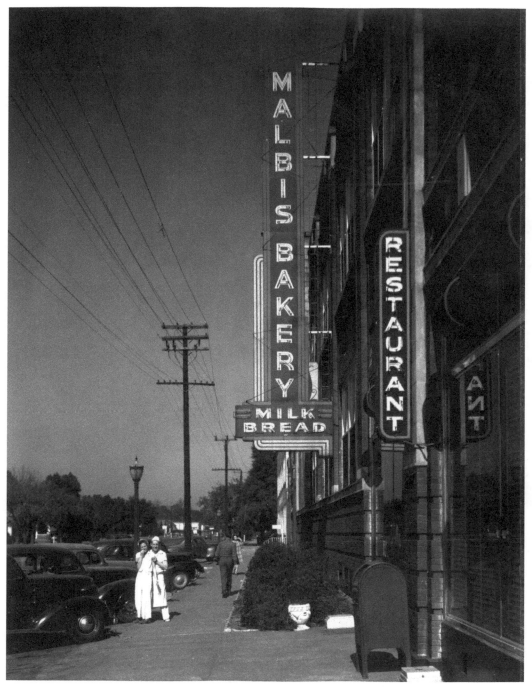

An employee with the Malbis Bakery stands outside as the photographer catches his image. Using $200,000 borrowed from a bank in Chicago, Jason Malbis, a Greek immigrant, established the business in 1927. Since Malbis was competing with a more well-established bread company, the going was tough at first, but within ten years the mortgage was paid off.

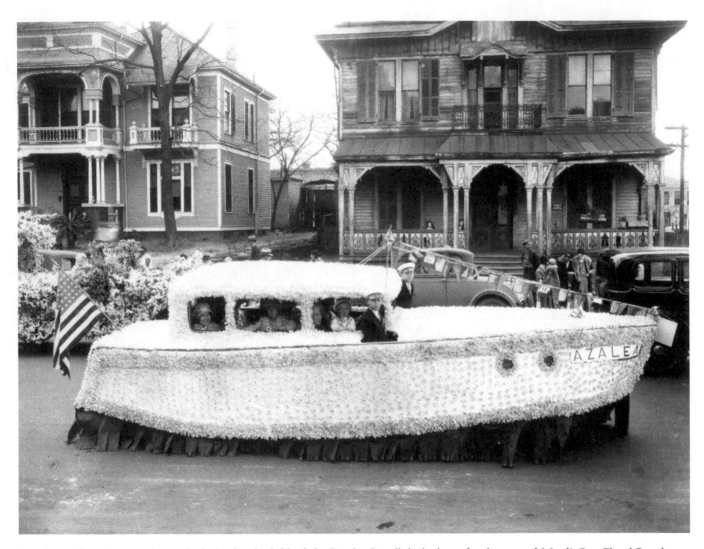

This beautifully decorated car, which the family dubbed the "Azalea," is all decked out for the annual Mardi Gras Floral Parade (ca. 1935).

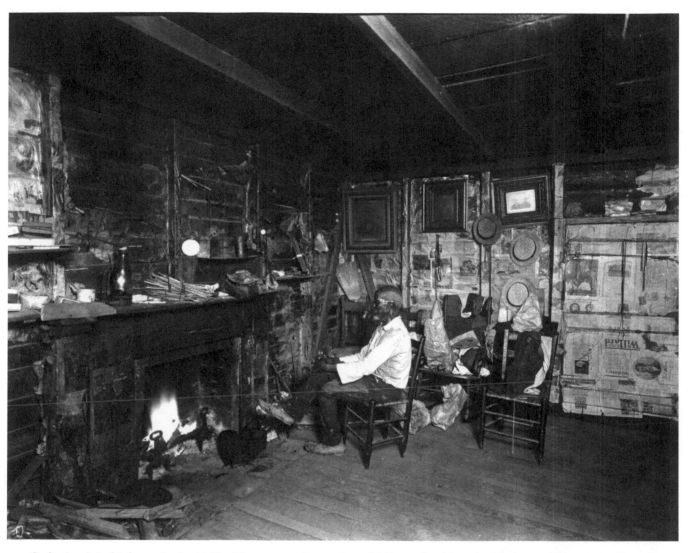

Cudjo Lewis in his home in the 1930s. He was one of a number of Africans that Timothy Meaher and Captain William Foster conspired to illegally smuggle into Mobile in 1860. They were brought from the coast of the African continent to the United States, landing in the Plateau/Magazine Point district north of the city. After the Civil War many of the Africans returned to that area and established a settlement they called Africatown. Cudjo became their spokesman.

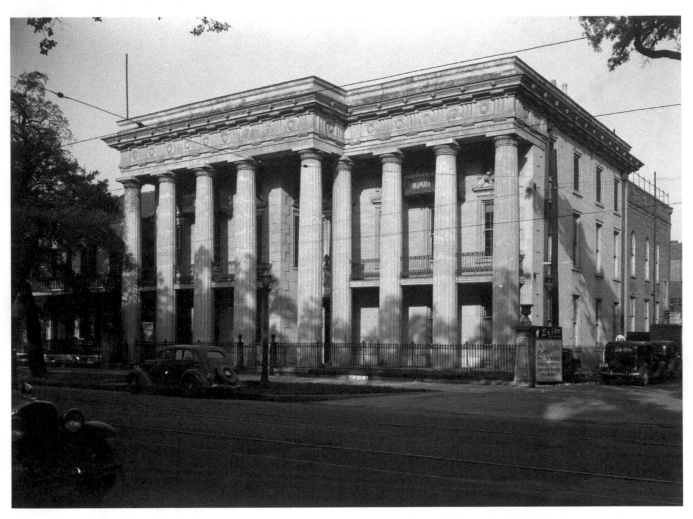

McGill Institute, a high school for Catholic boys, was constructed in 1896 and named for Arthur McGill, the owner of a shoe store who had bequeathed in his will the money necessary to build the structure. Until 1952 the school was located downtown, on Government Street. Due to increasing enrollment, it moved to its present location on Old Shell Road between Catherine and Lafayette. In the 1970s it combined with Bishop Toolen High School to become McGill-Toolen.

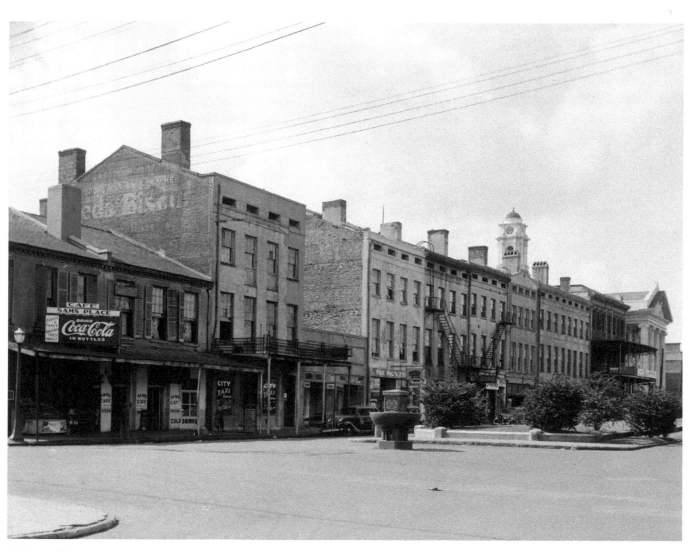

A view of Government Street in 1935, between Water and Royal streets. The block included Sam's Café, the City Taxi Service, the International Seaman's Union, and Pigs Eye Beverages.

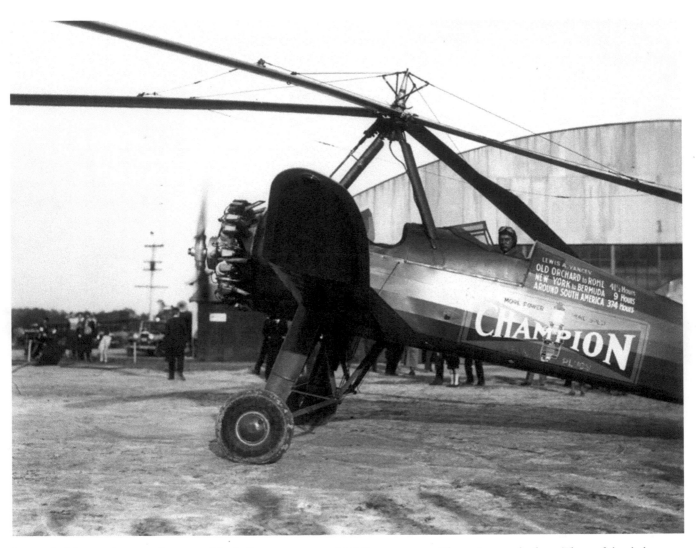

In 1936, this autogiro, a predecessor of the helicopter, came to Mobile to promote Champion spark plugs. The craft landed at Bates Field and offered rides to several Mobilians, including the proprietor of McGowin-Lyons Company, the largest local seller of Champion products. The pilot is Lewis Yancey.

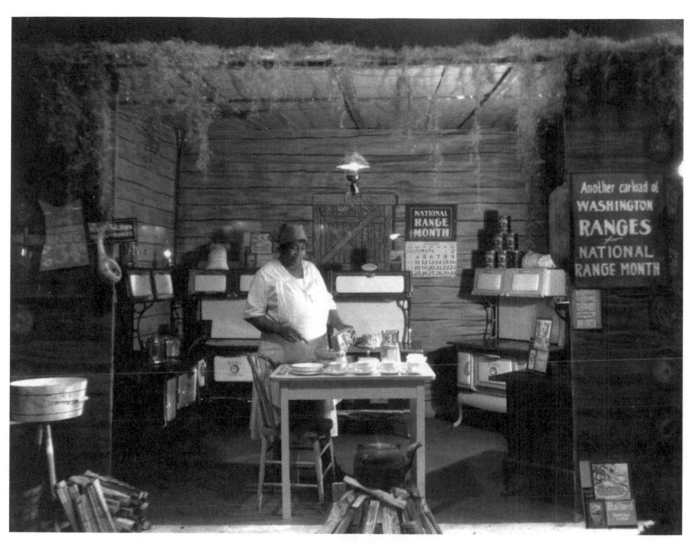

A woman pours Ballard Pancake Flour into a bowl during a promotional event for National Range Month, probably sponsored by the Mobile Gas Company. The woman is meant to appear as if housed in an authentic log cabin.

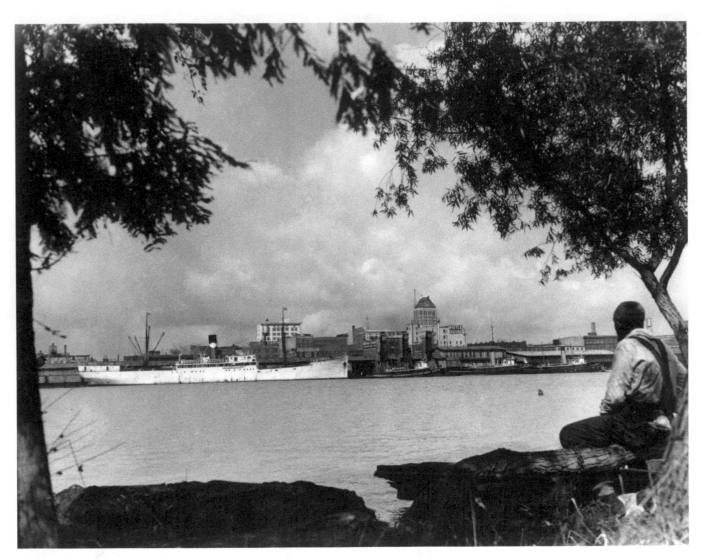

A view of the Mobile skyline taken from Pinto Island about 1935.

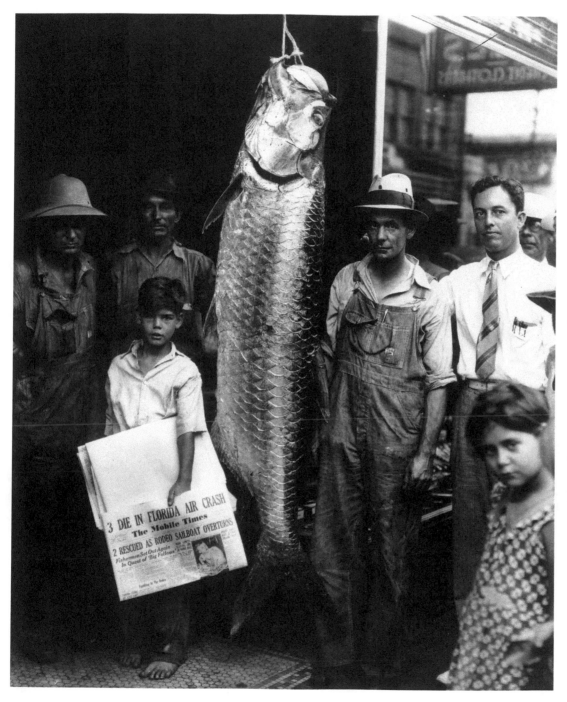

3 DIE IN FLORIDA AIR CRASH

The Mobile Times

2 RESCUED AS RODEO SAILBOAT OVERTURNS

Fishermen Set Out Again in Quest of "Big Fellows"

Two stories surround this photograph, which was taken in 1937. One says that the three men in overalls caught the huge tarpon. All three worked for the L&N Railroad. Another story has it that Jim Hare caught the fish and, because he was full-blooded Cherokee, stood silently in the back as the image was taken. It is said that all of Mobile turned out to see the big fish. Left to right (back row): M. Copeland, Jim Hare, A. F. O'Neal, and Eugene Thoss, Jr. The newsboy and the girl remain unidentified.

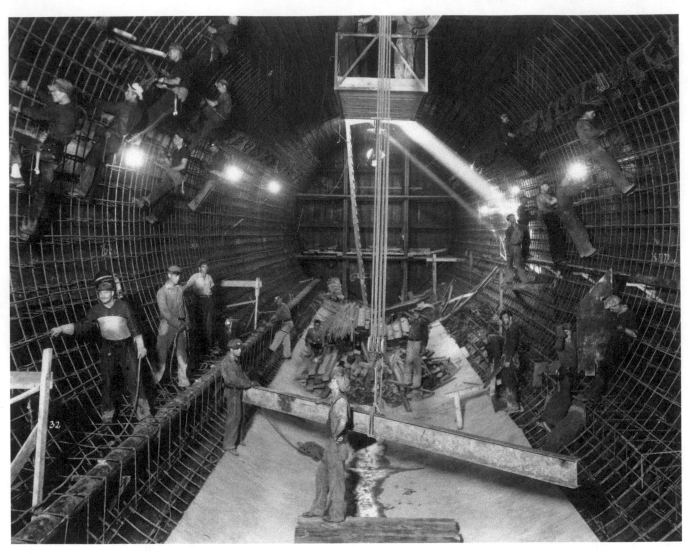

These men are working on a section of the Bankhead Tunnel, which allows traffic to pass under the Mobile River to points east of the city. The tunnel was a Works Progress Administration project begun in 1938 and completed in 1941. It cut seven miles off the previous route traveled over the Cochrane Bridge. After this tube section was finished, other men sunk it into the Mobile River and dragged it to its intended position.

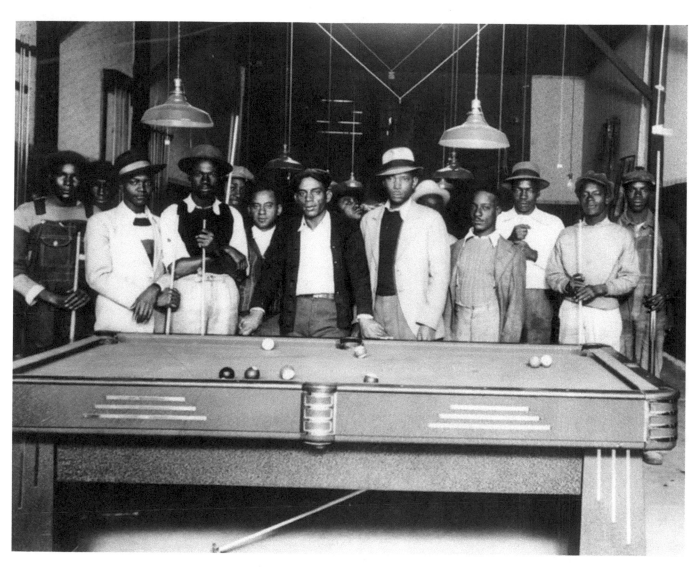

A group of pool players inside Jim's Billiards on Davis Avenue poses for a group shot in 1939.

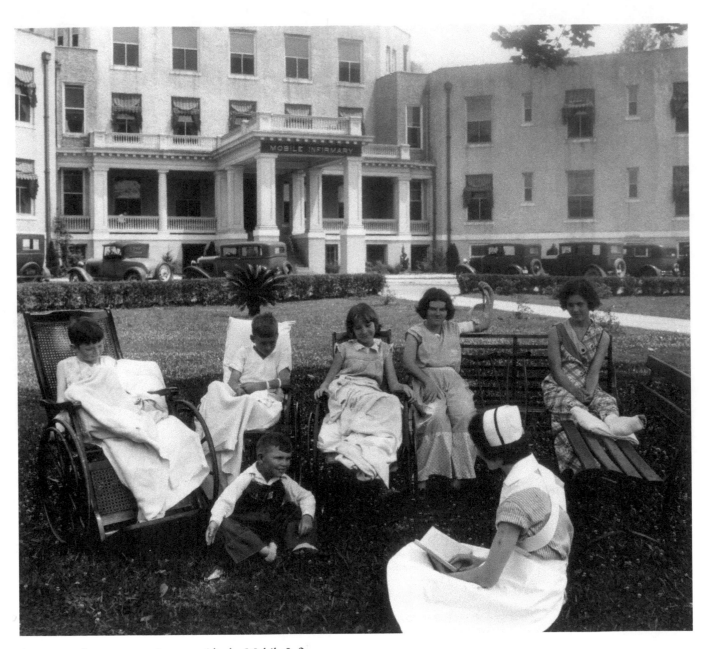

A nurse reads to young patients outside the Mobile Infirmary.

World War II and Beyond

(1940–1949)

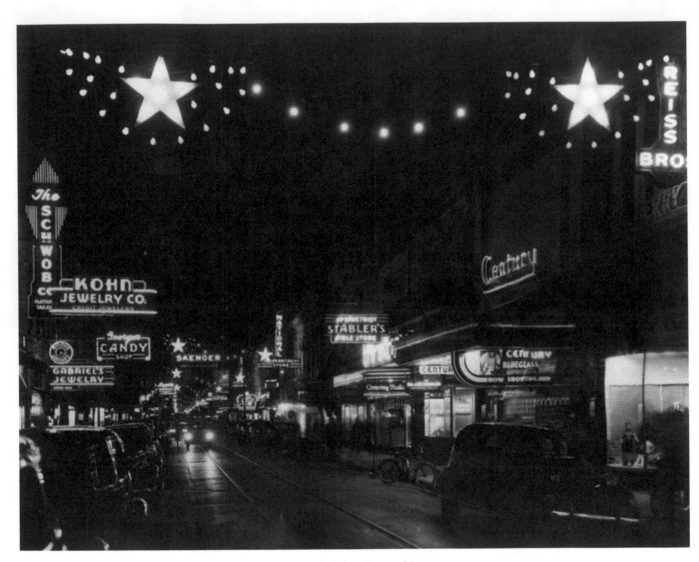

Dauphin between Conception and Joachim, lit up for the holidays (ca. 1940).

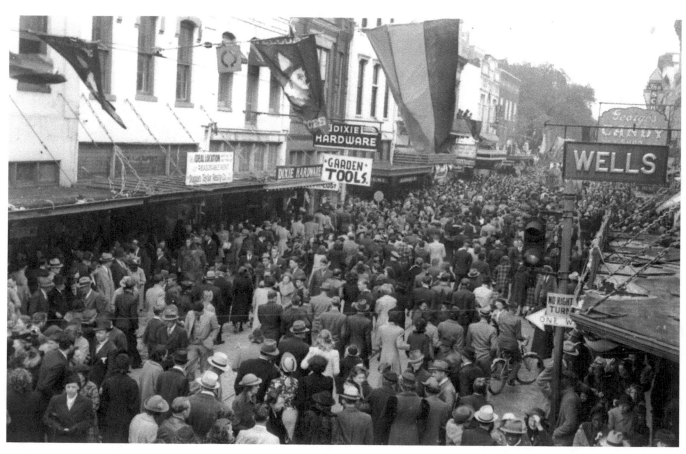

A crowd streams down Dauphin Street toward Bienville Square, probably during the Carnival season (ca. 1940).

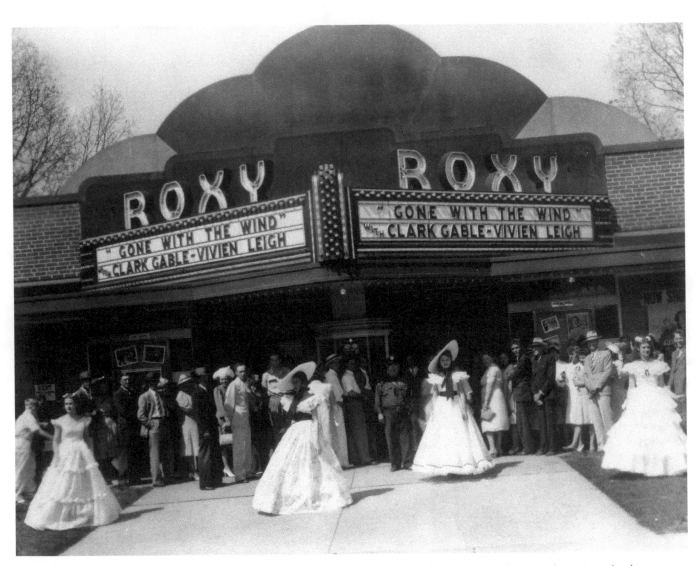

Like other Americans, Mobilians were taken with the movie *Gone with the Wind*. The winner of ten Academy Awards, the film eventually made its way to Mobile. In this 1941 photo, Azalea Trail maids pose in front of a crowd waiting to get into the Roxy Theater.

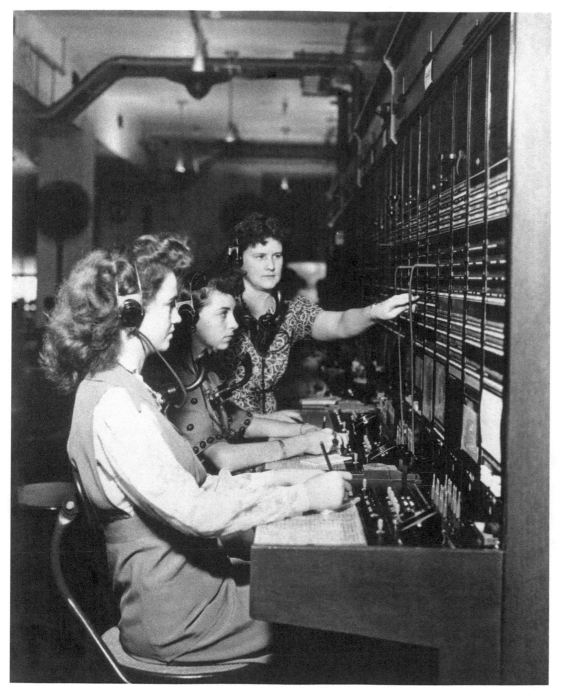

A supervisor with the Southern Bell Telephone Company instructs two women on how to connect phone calls, 1942 style.

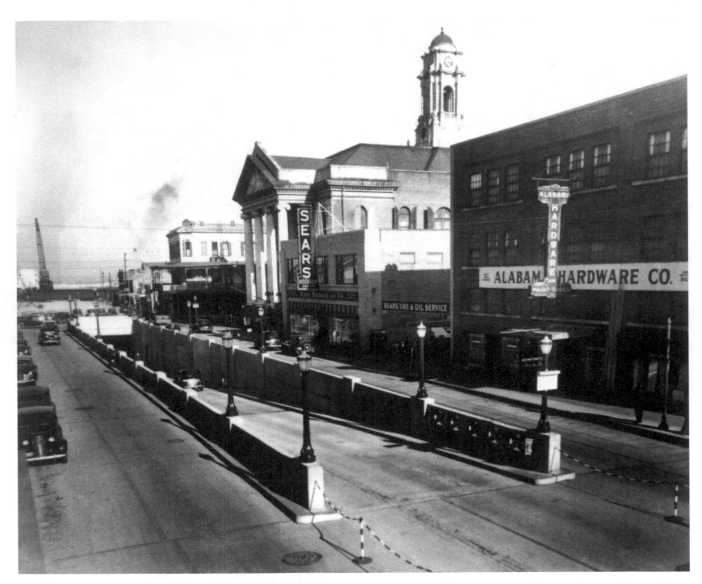

Government Street, looking east from the entrance to the Bankhead Tunnel (ca. 1942).

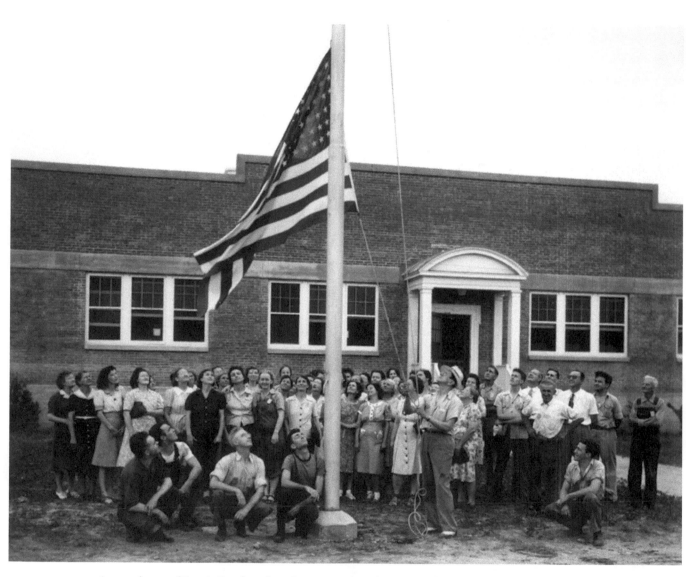

An employee of Bemis Brothers Bag Company raises the nation's flag as his fellow workers look on, May 5, 1943.

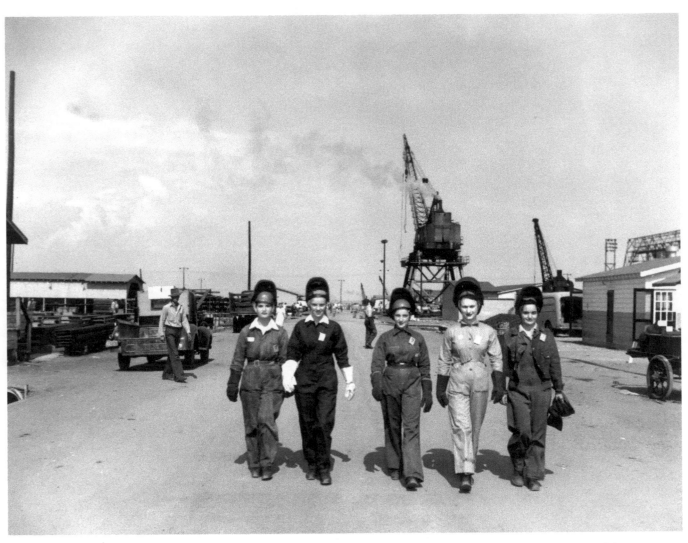

More than 60 women worked as welders at ADDSCO during World War II. These five women are representative of them.

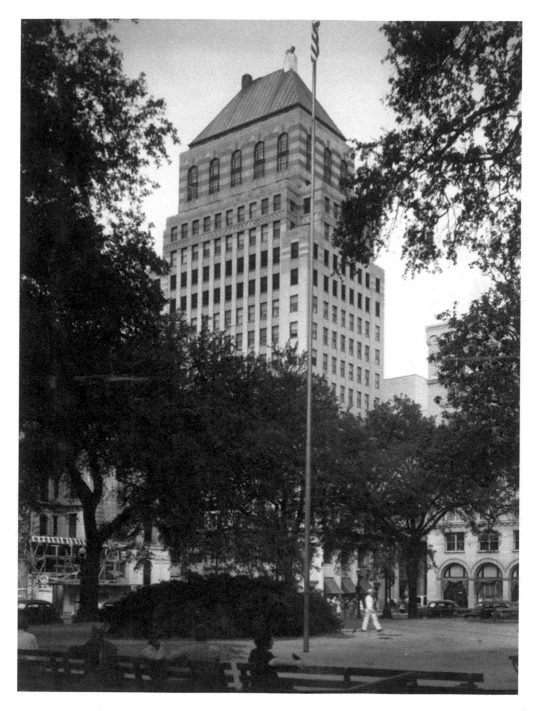

Built in 1929, the Merchants National Bank building looms over the scene as a sailor walks across Bienville Square around 1942.

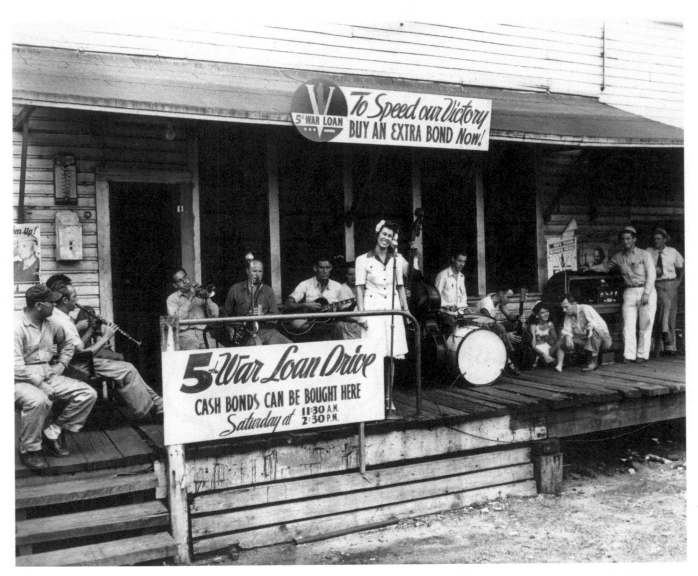

One of many bond rallies held at ADDSCO during World War II (ca. 1944). Such rallies were a common practice, helping to finance the conflict.

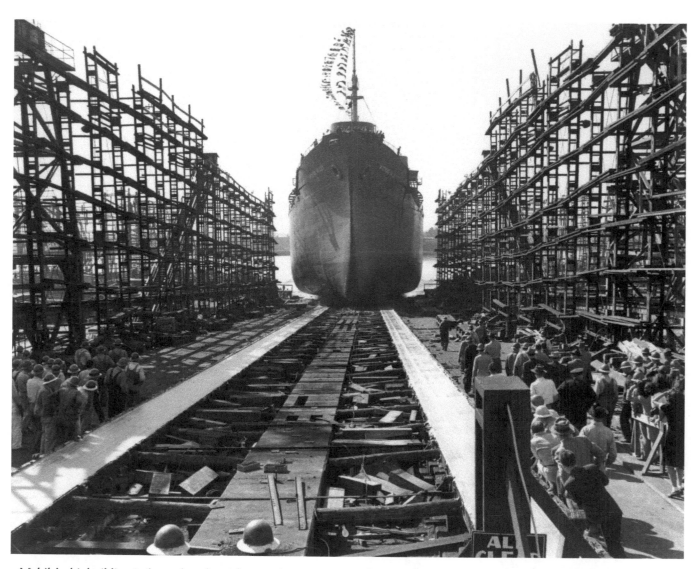

Mobile's shipbuilding industry has always been an important part of its economy. Here the tanker SS *Wyoming Valley* slides down the way on January 31, 1944. The ship was the 47th vessel built at ADDSCO during World War II, and was sponsored by the wife of city commissioner Charles Baumhauer.

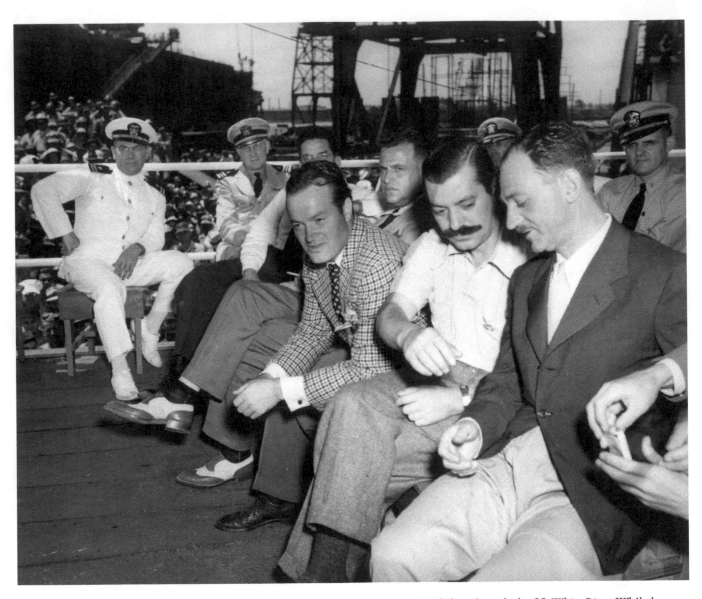

On March 1, 1944, Bob Hope, Jerry Colonna, and other entertainers came to Mobile to launch the SS *White River*. While here, Hope and his troupe entertained ADDSCO workers.

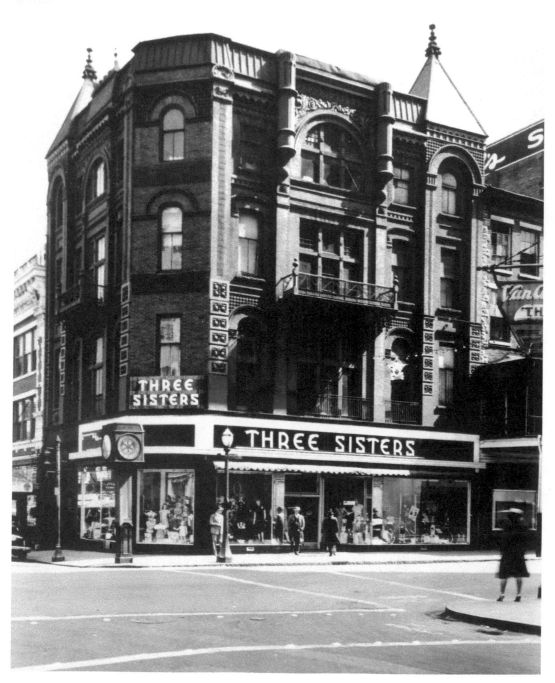

This elaborate Victorian building, constructed of brick and terra cotta, originally housed the Zadek Jewelry Company. In 1947, when this photo was taken, the Three Sisters clothing store occupied the site.

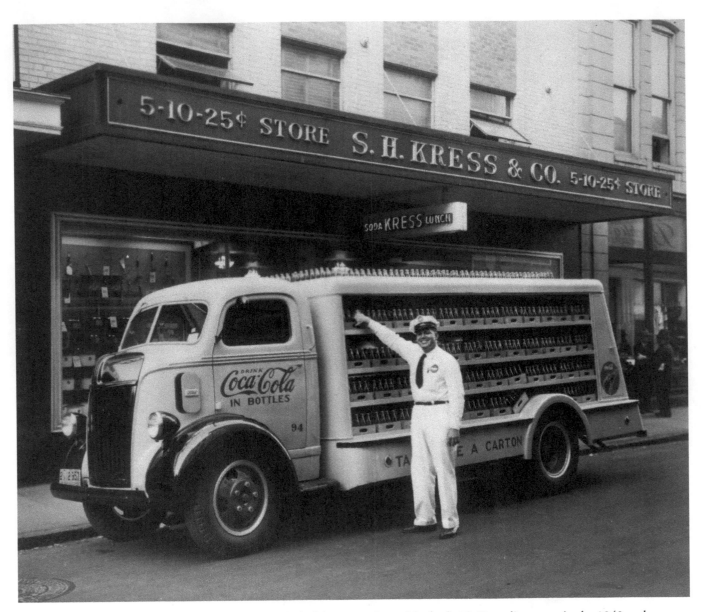

Driver Carlisle Dahmer stands in front of his Coca-Cola delivery truck outside the S. H. Kress dime store in the 1940s, when Coke was widely distributed in glass bottles.

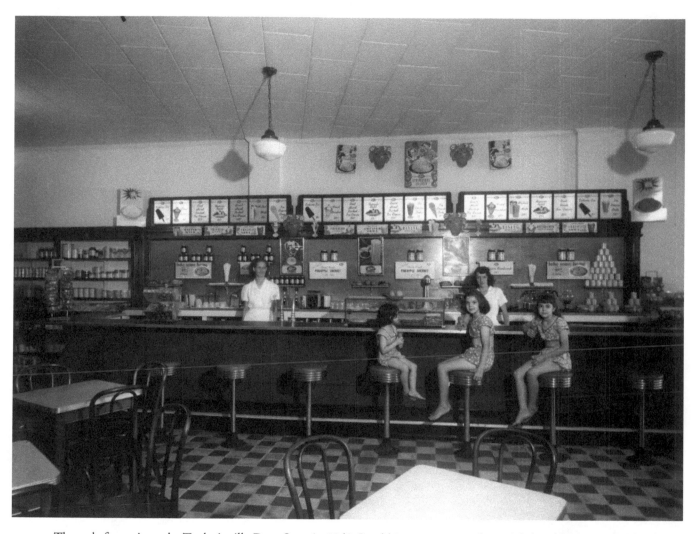

The soda fountain at the Toulminville Drug Store in 1948. It sold ice cream cones for a nickel and banana splits for thirty-five cents.

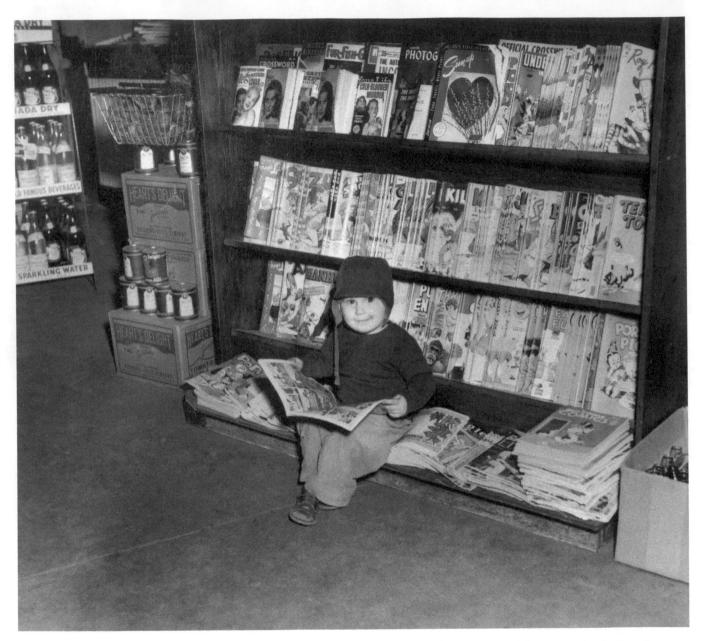

A youngster looks up from reading a comic book in the magazine section of a local grocery store. The smorgasbord of comics includes issue number two of *Marge's Little Lulu, Roy Rogers,* a number of pre–comics code titles, and *Walt Disney Comics and Stories,* at lower right, but few if any superhero titles.

From Opportunity to Stagnation

(1950–1969)

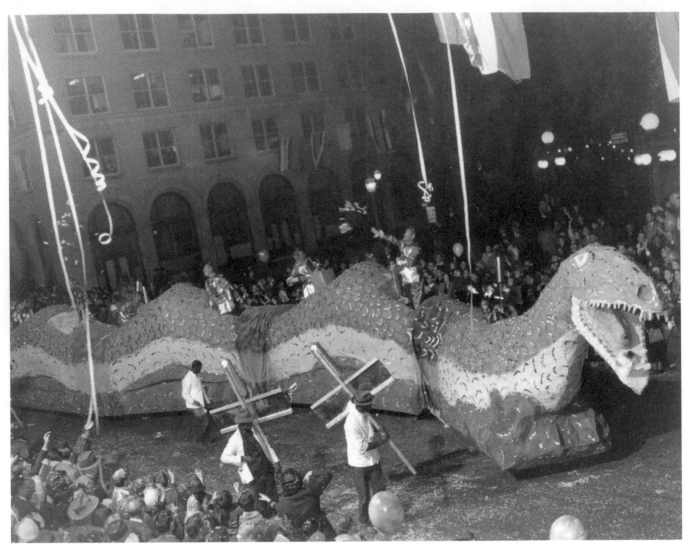

Vernadean—a combination of Verna and Dean—is the dragon associated with the Mystics of Time Mardi Gras society. It has been featured in their processions since the organization's first parade in 1949. Here she is in 1950, winding down the street as maskers throw trinkets to the crowd.

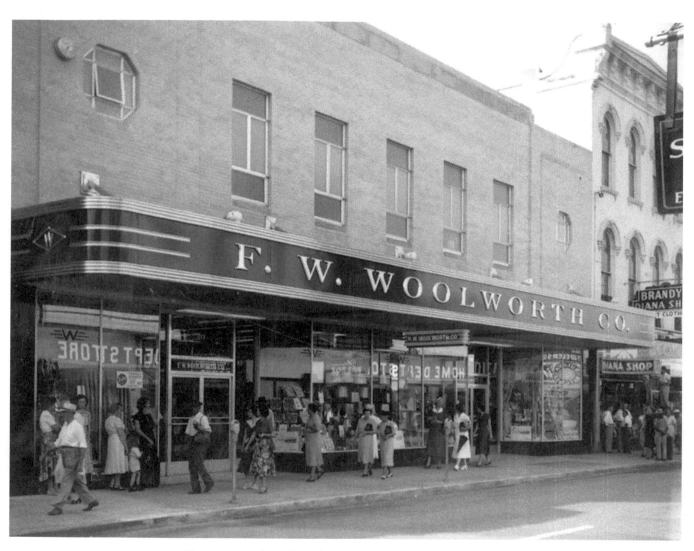

The exterior of Woolworth's Five and Dime in 1950, which was located then on Dauphin Street.

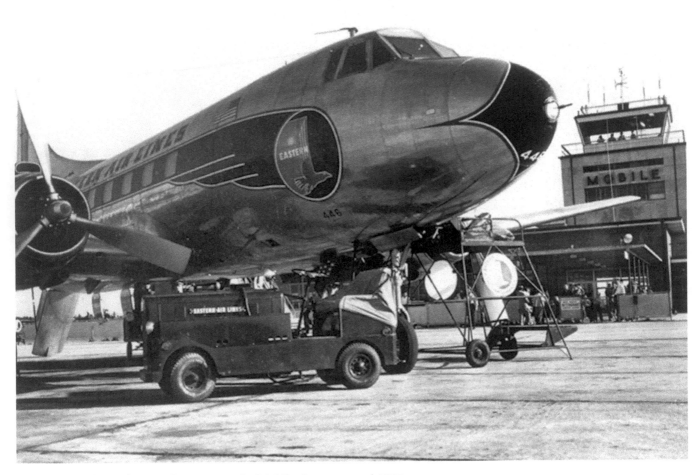

An Eastern Airlines plane on the tarmac at the Mobile airport around 1950.

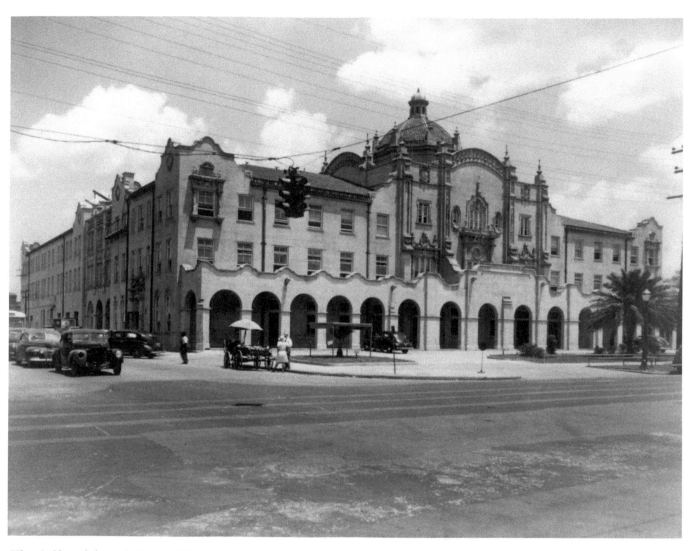

The Gulf, Mobile, and Ohio building as it looked around 1950. Fascinated with the Spanish Mission Revival style of architecture, Mobilians constructed the terminal in 1905. It is still in use as a transportation hub today.

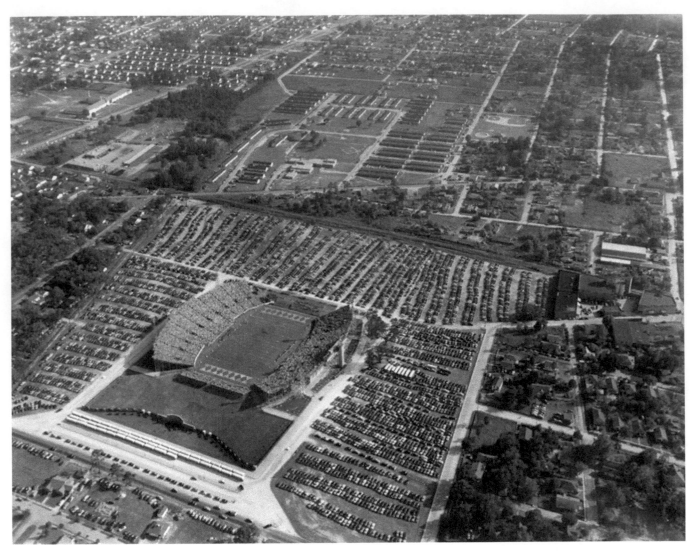

An aerial of Ladd Stadium, taken October 7, 1950. The occasion is probably a high school football game. Named in honor of Ernest F. Ladd, a former president of the Merchants National Bank, the stadium has been home to the Senior Bowl since 1951.

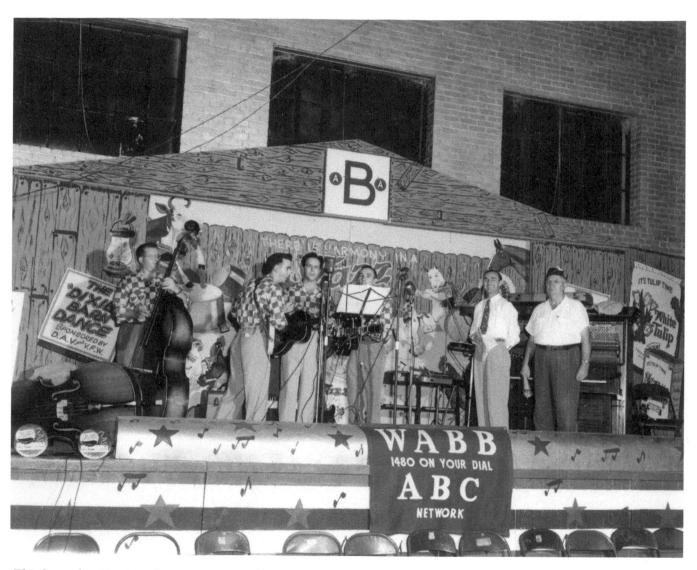

This September 11, 1952, dance was sponsored by the Disabled American Veterans and Veterans of Foreign Wars. It was probably held at Fort Whiting Auditorium. The band remains unidentified.

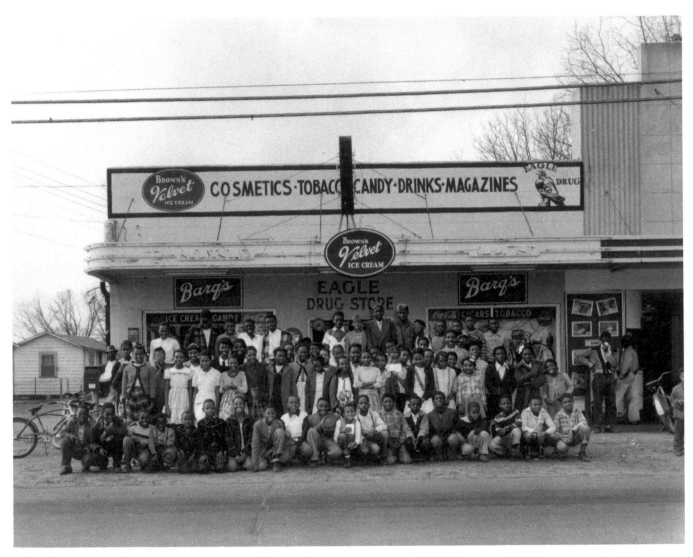

This group of children posed in front of the Eagle Drug Store on January 20, 1951. The reason for their congregation is lost to history, but, as the marker beneath the "Coca-Cola" sign reads, they may have been members of the Youth Training Club. Eagle Drug Store was located at 2801 St. Stephens Road in Toulminville.

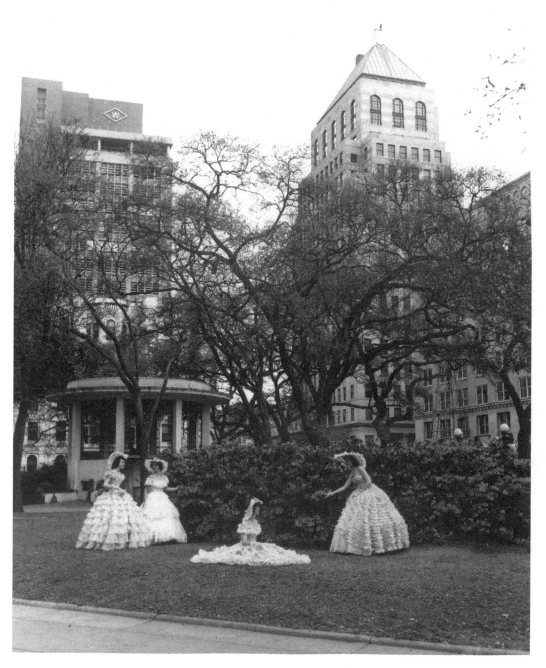

A group of 1951 Azalea Trail maids pose in Bienville Square in the shadow of the Waterman and Merchants National Bank buildings. Begun in 1929 as a means of attracting tourists, the trail helped contribute to the growth of the area's nursery industry and to Mobile's being known as the Azalea City.

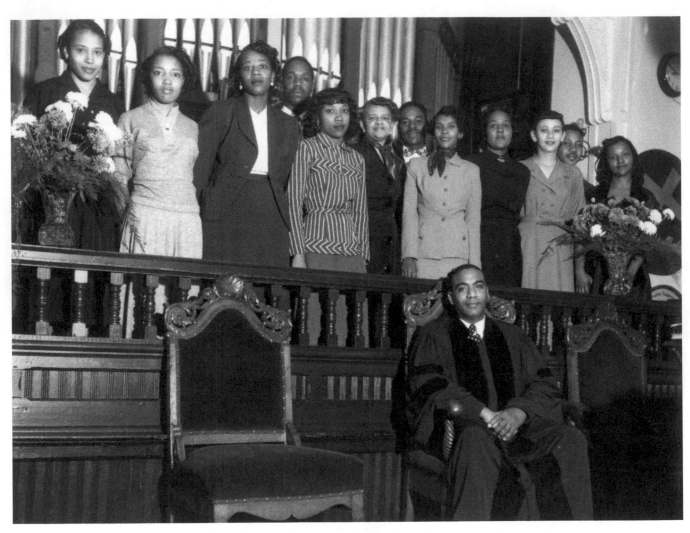

Members of the Big Zion AME choir, 1953. Bishop William Smith sits to the right.

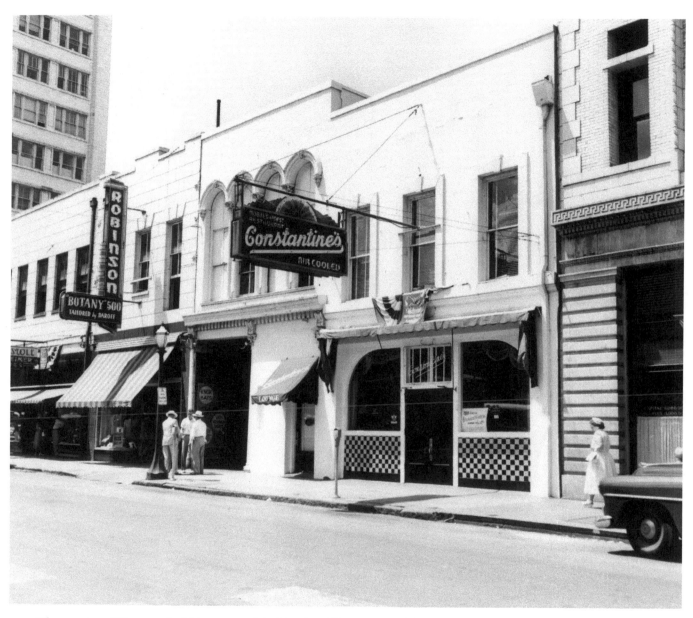

The exterior of Constantine's Restaurant, July 28, 1952. The restaurant's founder, Constantine Panayiotou, arrived in Mobile around 1932. He immediately opened a café at 80 St. Francis Street. By the time this image was taken, the business had moved to 9 Royal Street. The sign above the entrance displays the Stars and Bars and bids welcome to a Confederate group.

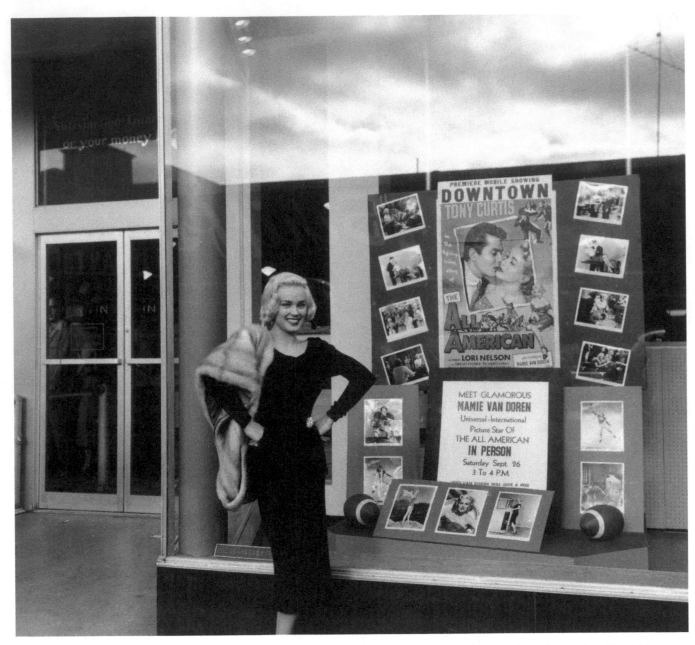

In town to promote her latest motion picture, actress Mamie Van Doren posed for this photograph on September 25, 1953.

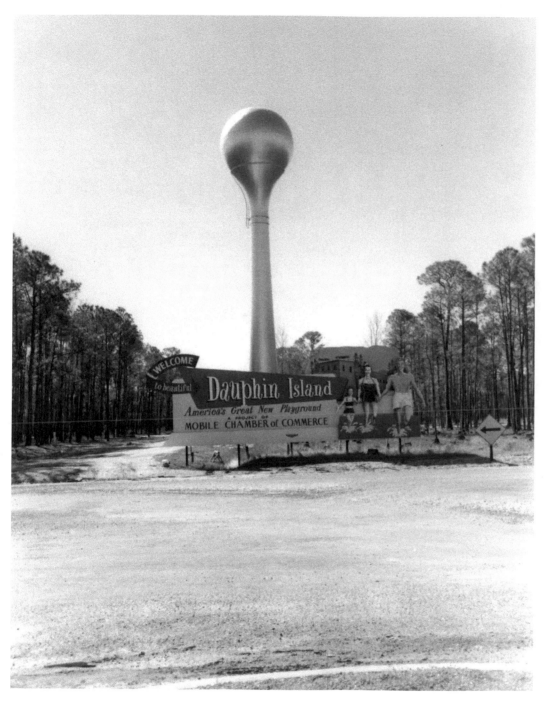

In the 1950s, this sign greeted visitors to Dauphin Island, Alabama, a barrier island in the Gulf of Mexico, long touted by the Mobile Chamber of Commerce as the Gulf Coast's "great new playground."

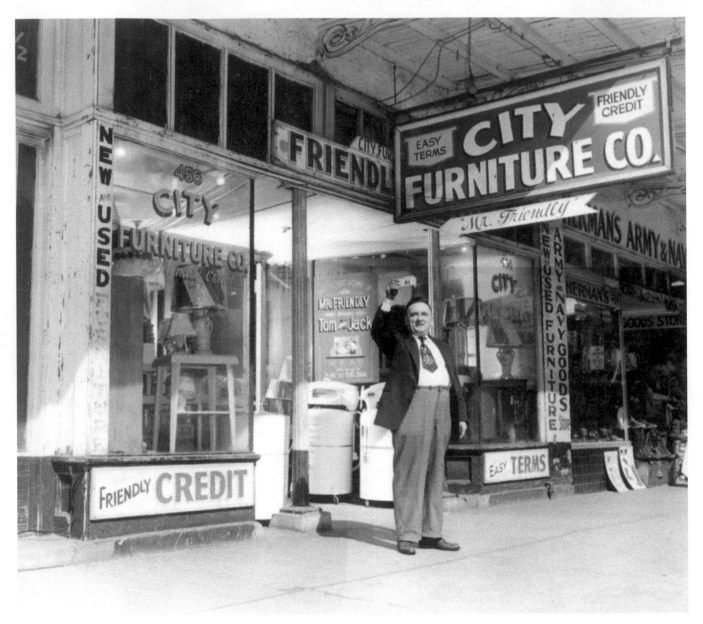

This happy fellow waving a dollar bill outside the City Furniture Company in February 1953 is probably "Mr. Friendly" himself. The business, located at 456 Dauphin Street, sponsored the Tom 'n' Jack show on WKAB radio. The February 1955 issue of *Cowboy Songs* magazine noted that Mobile recording artist Jack Cardwell's eight-room home had been completely furnished by the furniture store that had been his radio sponsor for seven years.

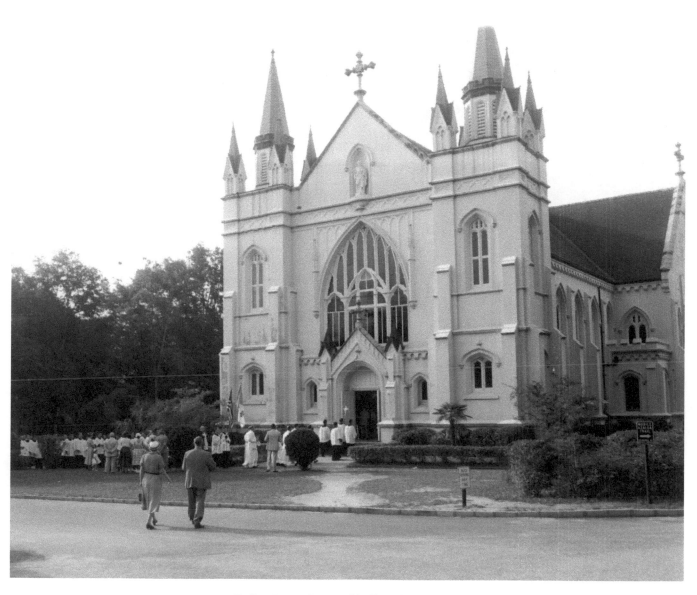

Ordination at St. Joseph's Chapel on the campus of Spring Hill College, June 16, 1954.

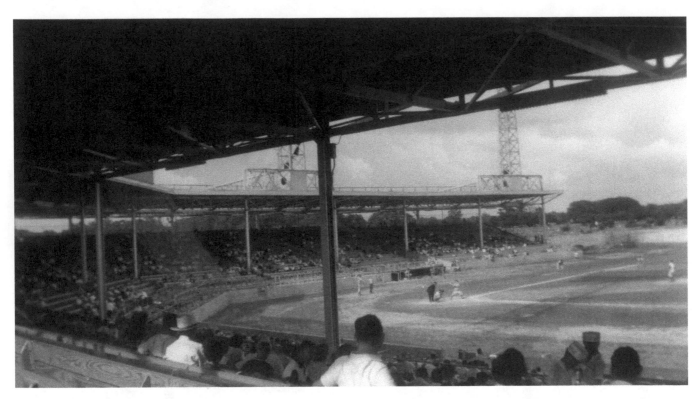

Baseball has been played in Mobile since at least the 1880s. This game—probably involving the Mobile Bears—was played at the old Hartwell Field in 1958.

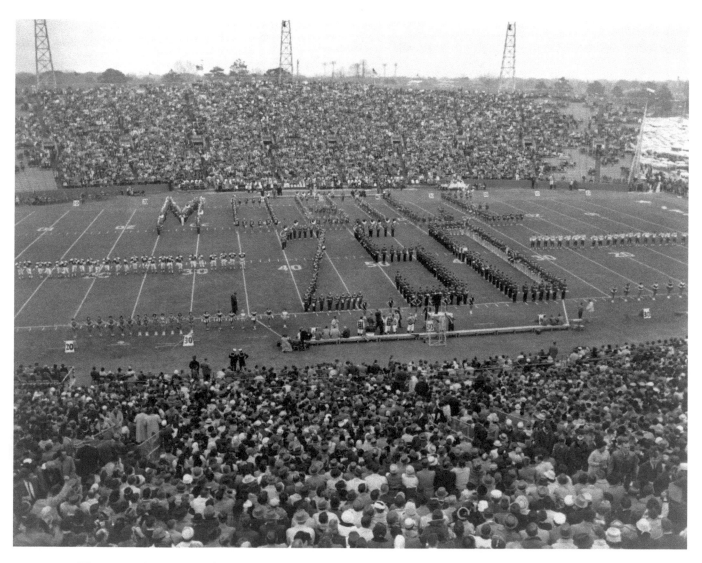

This image shows one of the events during Mobile's celebration of the 250th anniversary of its removal, in 1711, from Twenty-Seven Mile Bluff to its present location. Mayor Joseph Langan had decreed that all Mobile men grow beards and mustaches, uncommon in 1961, so that they would resemble the men who founded the city in 1702. This photograph was taken at Ladd Stadium.

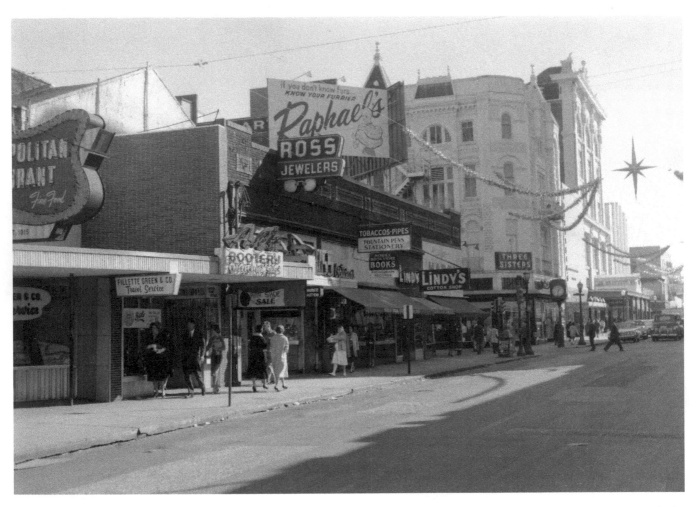

Royal Street, looking south toward Government around 1960. The Three Sisters is still in business and shares the preceding block with the Metropolitan Restaurant, Ross Jewelers, and Al's Bootery.

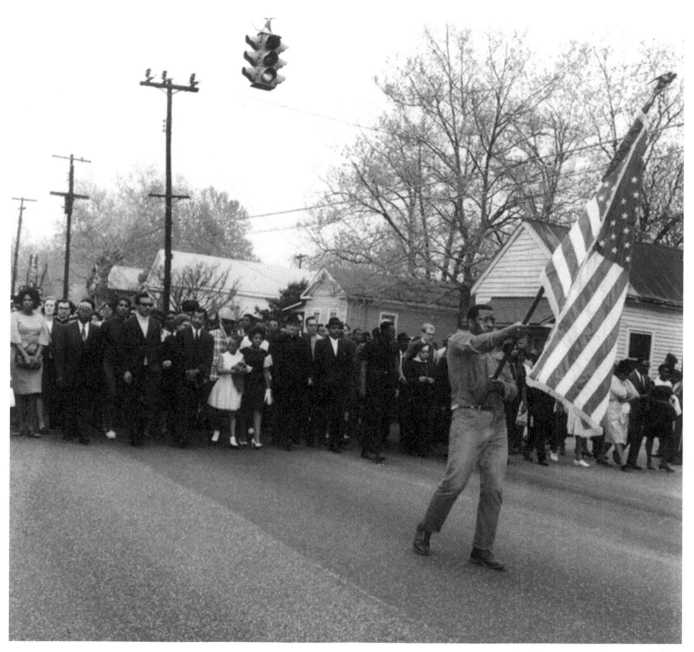

Members of the Mobile community march down Davis Avenue (now Martin Luther King Jr. Avenue) on April 7, 1968, in mourning after the assassination of the Reverend Dr. Martin Luther King, Jr. Jerry Pogue carries the flag.

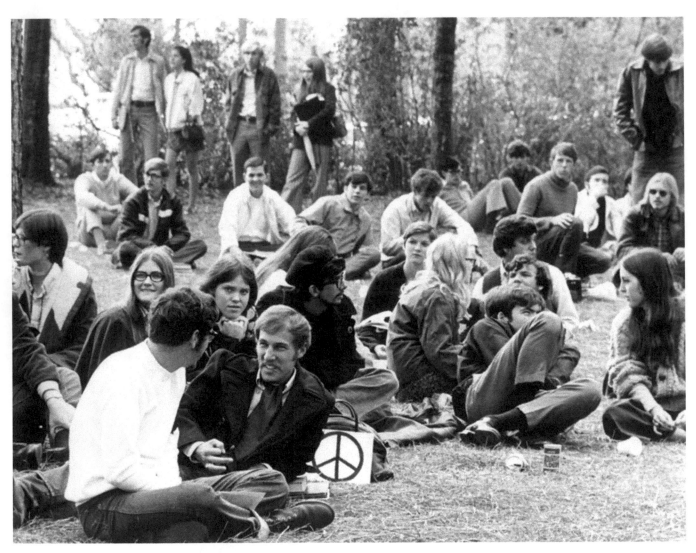

A group of University of South Alabama students "sit-down" in observance of the October 1969 Vietnam War Moratorium.

Notes on the Photographs

These notes, listed by page number, attempt to include all aspects known of the photographs. Each of the photographs is identified by the page number, a title or description, photographer and collection, archive, and call or box number when applicable. Although every attempt was made to collect all data, in some cases complete data may have been unavailable due to the age and condition of some of the photographs and records.

II **Panoramic from Cawthon Hotel**
University of South Alabama Archives
C9072G
Harris Photo, Conneaut, Oh.

VI **Empire Theater**
University of South Alabama Archives
N-1662

X **Moses Distributors**
S. Marion Coffin Collection
University of South Alabama Archives
SMC-46

2 **Cathedral of the Immaculate Conception**
Photo courtesy of F. V. White University of South Alabama Archives
C-5031

3 **Dockworkers**
University of South Alabama Archives
Windsor-11-30

4 **Government Street**
T. E. Armitstead Collection
University of South Alabama Archives
A-125

5 **Railroad**
T. E. Armitstead Collection
University of South Alabama Archives
A-22

6 **Fourth Mobile County Courthouse**
T. E. Armitstead Collection
University of South Alabama Archives
A-122

7 **Day's Catch**
T. E. Armitstead Collection
University of South Alabama Archives
C-17,080

8 **Smith's Bread**
Photo Courtesy of Jim Cool
University of South Alabama Archives
C-2109

9 **Oyster Boats**
Erik Overbey Collection
University of South Alabama Archives
G-2

10 **E. M. Hudson's Orchard**
T. E. Armitstead Collection
University of South Alabama Archives
A-159

11 **Fire**
S. Blake McNeely Collection
University of South Alabama Archives
C-4254

12 **Timber and Railroads**
T. E. Armitstead Collection
University of South Alabama Archives
A-317

13 **Salvation Army**
Erik Overbey Collection
University of South Alabama Archives
G-297

14 **Barton Academy**
T. E. Armitstead Collection
University of South Alabama Archives
A-56

15 **West Ward School**
T. E. Armitstead Collection
University of South Alabama Archives
A-57

16 **American Laundry Company**
Erik Overbey Collection
University of South Alabama Archives
C-34

17 **Mobile & Ohio Docks**
Mary Tucker Collection Clarke County Historical Society
Misc-104

18 **John Fowler**
Erik Overbey Collection
University of South Alabama Archives
N-3409B

20 **Dauphin Street**
Mobile: The Gateway to Panama (1900)
Courtesy of the Mobile Public Library
C-1161

21 MOBILE POLICE OFFICERS
Courtesy Mobile Public Library
C-7001

22 PEOPLE'S DRUGS
Erik Overbey Collection
University of South Alabama Archives
C-71

23 ST. JOSEPH STREET
Erik Overbey Collection
University of South Alabama Archives
G-344

24 GOVERNMENT STREET
S. Marion Coffin Collection
University of South Alabama Archives
SMC-238N

25 MOBILE CITY HALL
Library of Congress
LC-D4-19451

26 MONUMENT
Erik Overbey Collection
University of South Alabama Archives
G-494

27 HURRICANE DAMAGE
Courtesy of Larry Massey
University of South Alabama Archives
C-3257

28 KING'S FLOAT
Erik Overbey Collection
University of South Alabama Archives
N-3661

29 FLORAL DECORATIONS
Erik Overbey Collection
University of South Alabama Archives
C-4084

30 MONROE PARK
Photo by Erik Overbey; print courtesy of F. V. White
University of South Alabama Archives
C-16,047

31 WASHINGTON FIRE ENGINE COMPANY
Photo by E. W. Russell
Historic American Buildings Survey
Library of Congress
HABS AL-2

32 JOSEPH PATT'S VETERINARY HOSPITAL
Erik Overbey Collection
University of South Alabama Archives
G-207

33 BARKER MILL
Library of Congress
LOT 7479, v. 6, no. 3798

34 BARKER COTTON MILL INTERIOR
Library of Congress
LOT 7479, v. 6, no. 3829

35 SUNNY SOUTH
Erik Overbey Collection
University of South Alabama Archives
C-3003

36 TOY HORSE
Erik Overbey Collection
University of South Alabama Archives
G-419

37 CARLISLE CAFÉ
Courtesy of Tom Barkley University of South Alabama Archives
C-7

38 WRECKED AUTOMOBILE
Erik Overbey Collection
University of South Alabama Archives
N-5882

39 OPERATING ROOM
Erik Overbey Collection
University of South Alabama Archives
C-6007

40 JULY 4, 1916
Erik Overbey Collection
University of South Alabama Archives
G484

41 HURRICANE AFTERMATH
Erik Overbey Collection
University of South Alabama Archives
N-3861

42 GROCERY STORE
Courtesy of Wayne Meyer, University of South Alabama Archives
C-271

43 ADMIRAL RAPHAEL SEMMES MONUMENT
Erik Overbey Collection
University of South Alabama Archives
G-504

44 GULF CITY BICYCLE SHOP
Sherwood C. McBroom Collection,
University of South Alabama Archives
C-171

45 GOVERNMENT STREET RALLY
Erik Overbey Collection
University of South Alabama Archives
N-4258C

46 HAMMEL'S DELIVERY SERVICE
Hammel's Scrapbook
University of South Alabama Archives
C-10, 064

47 GENERAL STORE
University of South Alabama Archives
C-172

48 CELEBRATION
Erik Overbey Collection
University of South Alabama Archives
N-4254

49 FIRE FIGHTERS
University of South Alabama Archives
C-7014

50 CREOLE FIRE DEPARTMENT 100TH ANNIVERSARY
Erik Overbey Collection
University of South Alabama Archives
C-7004

52 SOUTH AMERICAN BANANA TRADE
Erik Overbey Collection
University of South Alabama Archives
N-242

53 GEORGE HARNESS & VEHICLE COMPANY
Erik Overbey Collection
University of South Alabama Archives
N-1751

54 BAY QUEEN
Erik Overbey Collection
University of South Alabama Archives
C-3197

Printed in the USA
CPSIA information can be obtained
at www.ICGtesting.com
JSHW072025140824
68134JS00042B/3786